The Conservation of
Tapestries and Embroideries

The Conservation of Tapestries and Embroideries

Proceedings of Meetings at the
Institut Royal du Patrimoine Artistique
Brussels, Belgium
September 21-24, 1987

THE GETTY CONSERVATION INSTITUTE

Front Cover: Tunic Burgundian vestments, detail.
Schatzkammer, Kunsthistorisches Museum,
Vienna, inv. Pl 15.

Back Cover: Reverse of antependium, label from
seventeenth-century repair. Schatzkammer,
Kunsthistorisches Museum, Vienna.

Symposium Coordinator: Liliane Masschelein-Kleiner, Institut Royal du
Patrimoine Artistique, Brussels, Belgium
Publications Coordinator: Irina Averkieff, The Getty Conservation
Institute, Marina del Rey, California
Training Program Coordinator: Suzanne Deal Booth, The Getty
Conservation Institute, Marina del Rey, California
Editor: Kirsten Grimstad
Technical Drawing: Janet Spehar
Design: Terry Irwin and Leah Hofmitz, Letterform Design,
Los Angeles, California
Typography: Ventura/Adobe Postscript Stone Serif and
Univers Condensed
Printing: Dai Nippon, Tokyo, Japan

Library of Congress Cataloguing-in-Publication Data

The Conservation of tapestries and embroideries.
1. Ecclesiastical embroidery—Conservation and restoration—
Congresses. 2. Tapestry—Conservation and restoration—Congresses.
I. Institut royal du patrimoine artistique (Belgium)
II. Getty Conservation Institute.
NK9310.C66 1989 746.44'0488 89-2058 ISBN 0-89236-154-9

The article by Mechthild Flury-Lemberg, "The Restoration of the An-
tependium of the Musée Paul Dupuy in Toulouse," appeared in *Textile
Conservation and Research* and an edited version is reprinted here with
the permission of the Abegg Foundation. The article also appeared in
the *Bulletin de Liaison du CIETA* and is reedited and reprinted here with
the permission of the Centre International d'Etude des Textiles
Anciens.

THE GETTY CONSERVATION INSTITUTE

The Getty Conservation Institute (GCI), an operating
organization of the J. Paul Getty Trust, was created in
1982 to enhance the quality of conservation practice
in the world today. Based on the belief that the best
approach to conservation is interdisciplinary, the
Institute brings together the knowledge of conserva-
tors, scientists, and art historians. Through a combi-
nation of in-house activities and collaborative
ventures with other organizations, the Institute plays
a catalytic role that contributes substantially to the
conservation of our cultural heritage. The Institute
aims to further scientific research, increase conserva-
tion training opportunities, and strengthen com-
munication among specialists.

Contents

Foreword

Luis Monreal, Director
The Getty Conservation Institute

The restoration of four historically significant Renaissance textiles in the work-
shop of the Institut Royal du Patrimoine Artistique (IRPA) provided the occa-
sion for a gathering of twenty-seven conservators, conservation scientists, and
curators from museums and tapestry and embroidery conservation workshops in
Western Europe and the United States. Organized by the director of the Institut
Royal, Liliane Masschelein-Kleiner and cosponsored by the Getty Conservation Insti-
tute, the four-day seminar took place September 21–24, 1987, in Brussels—a location
that offered an especially meaningful backdrop because of its historic role as a
tapestry-weaving center. On-site visits to the IRPA textiles workshop, the private work-
shop Gaspard De Wit in Mechelen, the "Tissus d'Or" exhibition at the Royal
Museums of Art and History (featuring the four works restored at the IRPA workshop),
and the "Masterpieces of Bruges Tapestry" exhibition at the Gruuthuse Museum and
the Memling Museum in Bruges bore testimony to the issues raised at the working
sessions.

The seminar was designed as a forum for participants to present their current
research and treatments, address urgent issues that have not yet received sufficient
attention from the profession, scrutinize new findings, and thoroughly discuss
specific problems, innovations, methods, materials, and technologies that might be
proposed in the course of the meetings. In other words, the seminar aimed at estab-
lishing the present state of knowledge in the field. Several of the participants had
attended a previous textile study group held at the J. Paul Getty Museum in 1984 at
which specific issues for further research—support materials, surfactants, the in-
fluence of aging, the degradation of synthetic polymers, training and standards of
practice, and methods of "slowing down" the degradation of large textiles—were iden-
tified. Participants in the Brussels seminar followed up on many of these issues.

The fifteen papers published in this volume formed the armature for this
creative exchange. They focus on treatments of western European tapestries and eccle-
siastical embroideries, mostly from the Renaissance period, although one work, a litur-
gical sandal, dates back to the twelfth century, while the pilaster panels from Broni
originated as recently as the 1740s. Some of the papers present general concerns, such
as the development of a comprehensive conservation program for textiles at the
Metropolitan Museum of Art (Nobuko Kajitani) or the importance of compiling a

thorough technical report (Stephen Cousens). Most offer recent treatments of important historic textiles as case studies in the state of the art of textiles conservation.

From this mixed palette of expertise, certain dominant tones stand out. Perhaps above all, participants share a concern over the perils and rewards of wet cleaning versus dry cleaning. Simply stated, the procedure that may be necessary to preserve the object from further deterioration may also run the risk of altering it irreversibly. Not surprisingly, thoughts concerning cleaning technology and procedure weave a thematic pathway through many of these papers (Marie Schoefer and Eric Houpeaux, Nobuko Kajitani, André Brutillot, Loretta Dolcini, Bruce Hutchison, Ksynia Marko, and Yvan Maes). Likewise, the pervasive problem of reintegrating large areas of loss in tapestries sparked common concern and innovative approaches, as found especially in the papers presented by Ksynia Marko and Yvan Maes.

Interest in the issues of mounting, display, and storage form another thread of continuity among the papers. These issues are sometimes regarded as being outside of the radius of work of the individual textile conservator. Nonetheless, fragile tapestries and embroidered textiles, such as the reconstructed fragments of the twelfth-century liturgical sandal salvaged from a bishop's tomb (Marie Schoefer and Denise Lestoquoit), require custom-designed backing, mounting, and showcases made of materials that offer optimum protection for their vulnerable displays. The conservator's interest in controlling environmental conditions extends beyond the exhibition rooms to include storage areas as well as works in transit. Attention to these conditions is a requisite of the field. Curators are becoming aware of the textile conservator's role in the continuing preservation of the object once it has been restored (Nobuko Kajitani).

The nuances of individual interests expressed in these papers offer evidence of the broad range embraced by this topic. Karen Finch, for example, exposes some of the special problems caused by Victorian textile censors who rewove discrete portions of a tapestry depicting Cleopatra provocatively resting her leg in Anthony's lap. When the inferior nineteenth-century dyestuffs faded away, the naughty leg reappeared in a blushing shade of pink. Mechthild Flury-Lemberg traces clues to the origin and history of the Toulouse antependium in its uncommon depictions of scenes from the lives of Saint Francis and Saint Clare. Rotraud Bauer surveys certain historic embroidery techniques—needle painting and *or nué*—as found on a set of fifteenth-century ecclesiastical vestments displayed in the Schatzkammer in Vienna. Francesco Pertegato notes evidence of division of labor and time-saving needlework techniques practiced in the eighteenth-century Italian embroidery workshop where the Broni pilaster panels were produced. Yvan Maes diagnoses present-day productivity needs that apply not only to commercial restoration workshops but also, in his opinion, to the field as a whole if the world's heritage of textile art is to receive the attention it so obviously and urgently requires. Among the remedies drawn from experience in his private workshop are methods for achieving custom color effects without the painstaking and labor-intensive process of custom-dyeing yarns to specific shades.

The recent treatments presented here encompass noteworthy triumphs, such as the recovery of a thirteenth-century masterpiece of embroidery—the Toulouse antependium—which was disguised beneath a crudely worked layer of overstitching like a diamond in the rough. They also include the failures that nonetheless serve to broaden knowledge, such as the efforts described by Ksynia Marko to remove thick coats of adhesive from a tapestry. Between these widespread poles marking off the territory surveyed in these papers lies a field of new information, culled from the workshops of advanced practitioners, presented and published here to further the state of knowledge in this discipline.

Plate 1, right. Detail of the altar frontal from Middelburg. One of the two faces embroidered directly onto the lining.

Plate 2, above. Central panel of the altar frontal from Herkenrode showing the Last Supper on the blue support lining, before treatment.

Plate 3, far right. Detail of the right-hand edge of the Toulouse antependium showing 4 cm of the original embroidery next to the nineteenth-century restoration (on the left). A silk tape trimming was used to cover the embroidered outlines framing the quatrefoils.

Plate 4, right. Section of the Toulouse antependium showing the original embroidery restored: The Crucifixion and the removal of Christ from the cross appear in the lower row of quatrefoils, with the crucifixion of Saint Peter in the gyron above.

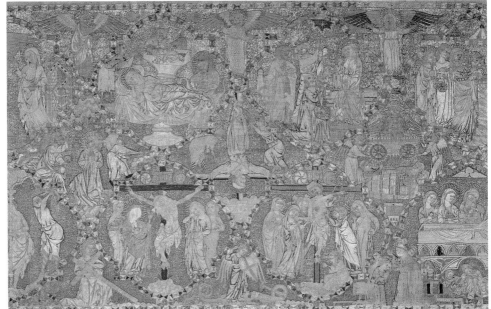

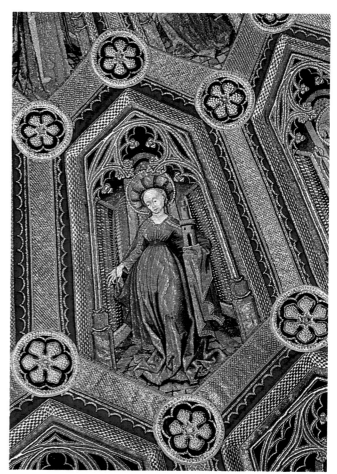

Plate 5, top. View of the room where the Burgundian vestments are exhibited, Schatzkammer, Kunsthistorisches Museum, Vienna.

Plate 6, above. Cope of Mary, detail of back. Note the yellow stitches on the pink linen lining that refer to the later addition of a net of gold laidwork superimposed on the original gold braids. The white stitches indicate repeated attempts to anchor the pearls. Dark lines indicate areas where outlines have been restored.

Plate 7, top right. Cope of Mary, detail showing Saint Barbara. Note the appliquéed red velvet ribbons with ornamental gold embroidery, the blue velvet disks with pearl rosettes, and the net of gold thread laidwork on top of the original gold braids (inv. Pl 21).

Plate 8, far right. Chasuble, detail of the back showing an example of Lazurtechnik, also called or nué.

Plate 9, right. Chasuble, or nué technique: parallel laid gold threads are couched two by two with silk stitches.

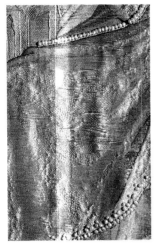
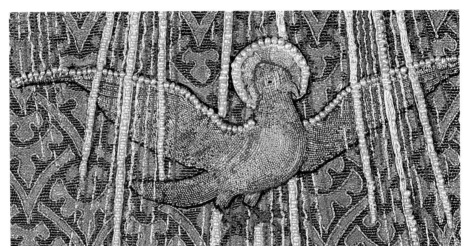

Plate 10, *top. Chasuble, detail. Face of an angel originally stitched in needle painting technique; most of the silk stitches have worn away, leaving the linen ground textile visible.*

Plate 11, *top right. Chasuble, detail. Old restoration stitches in thick yellow silk thread.*

Plate 12, *above. Chasuble, detail. Old restoration stitches sewn with thick thread in an or nué area.*

Plate 13, *above right. Chasuble, detail showing restoration work of the 1960s. Many of the silver threads of the body of the dove—which is filled with threads and molded three-dimensionally—are couched with new silk stitches.*

Plate 14, *right. Chasuble, detail showing restoration work of the 1960s. New dark-brown silk restores the outlines and the inscription.*

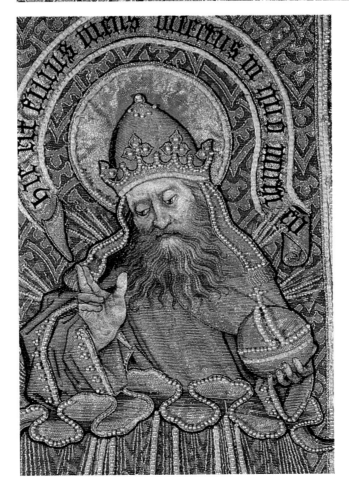

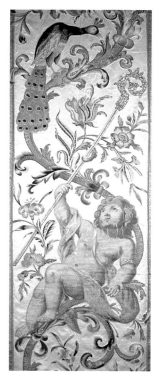

Plate 15, above. Broni (Pavia), Church of San Pietro. Panel 1 decorated with embroidery in gold thread and colored silk and with painted satin-weave silk. Northern Italy, circa 1740–1750.

Plate 16, above right. The reverse of a panel, detail. The embroidery techniques include both stitching directly onto the basic fabric (gold ribbon) and sewing preembroidered elements (colored silk leaves and flowers) to the fabric.

Plate 17, right. A section of painted satin-weave silk in which fragments are in danger of falling away.

Plate 18, far right. As in Plate 17, following conservation.

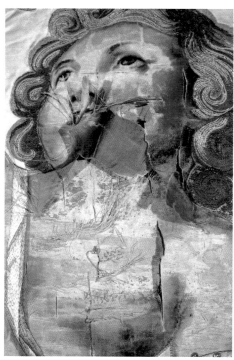

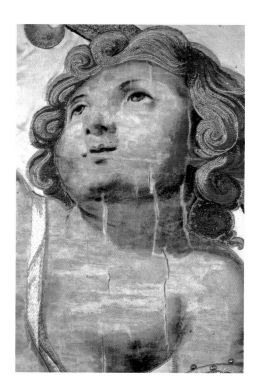

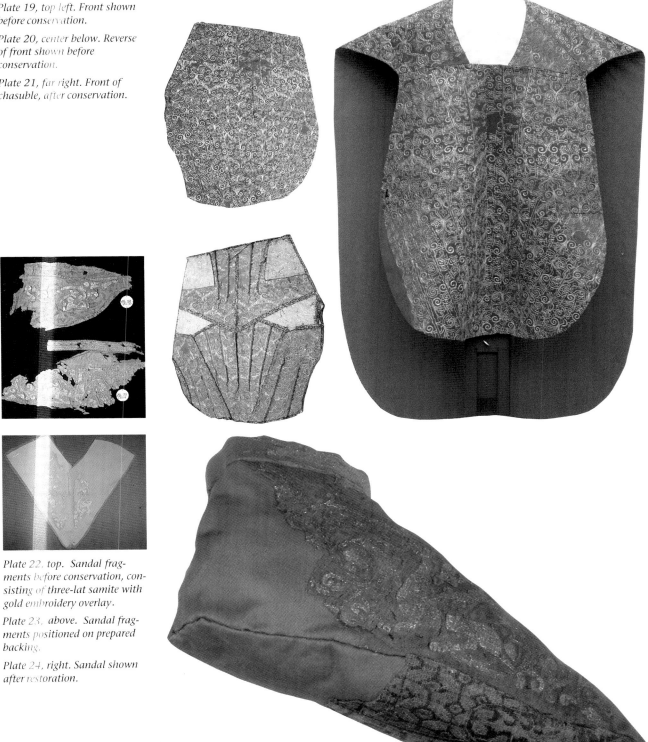

Plate 19, top left. Front shown before conservation.

Plate 20, center below. Reverse of front shown before conservation.

Plate 21, far right. Front of chasuble, after conservation.

Plate 22, top. Sandal fragments before conservation, consisting of three-lat samite with gold embroidery overlay.

Plate 23, above. Sandal fragments positioned on prepared backing.

Plate 24, right. Sandal shown after restoration.

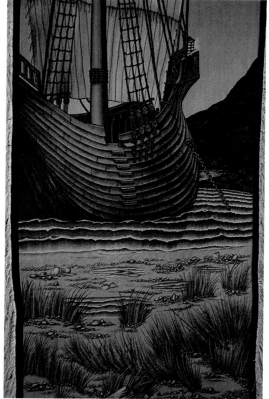

Plate 25, top right. Solebay tapestry. Repairs draw attention through their block formation.

Plate 26, above. Tapestry with Anthony and Cleopatra, originally woven with Cleopatra's leg across Anthony's knee. The original weaving was completely removed and the area rewoven as part of Anthony's garment. Subsequent color changes revealed the outline of the leg.

Plate 27, right. Ship tapestry. Tensions set up by the naturalistic weaving of the grass cause this narrow tapestry to twist when hung.

Plate 28, below. Gnadenstuhl overview before conservation.

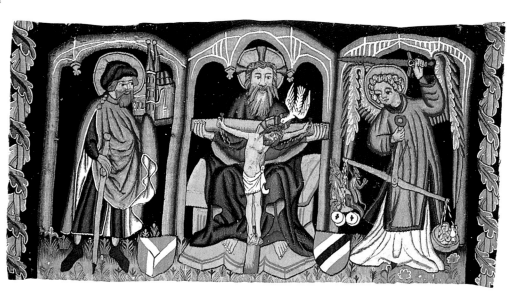

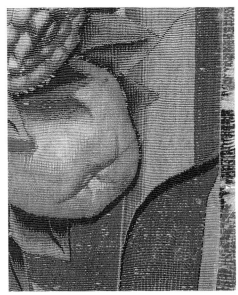

Plate 29, top. The Dream of the Sheaves of Corn. *1:6 reduced scale drawing of the tapestry.*

Plate 30, above. Detail of the tapestry showing damaged area.

Plates 31, 32, top. Small areas where reweaving is carried out.

Plates 33, 34, right. Damaged weft areas treated with wide-weft reweaving technique.

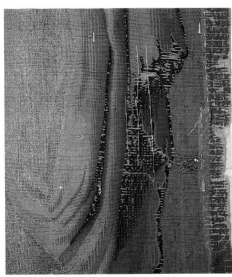

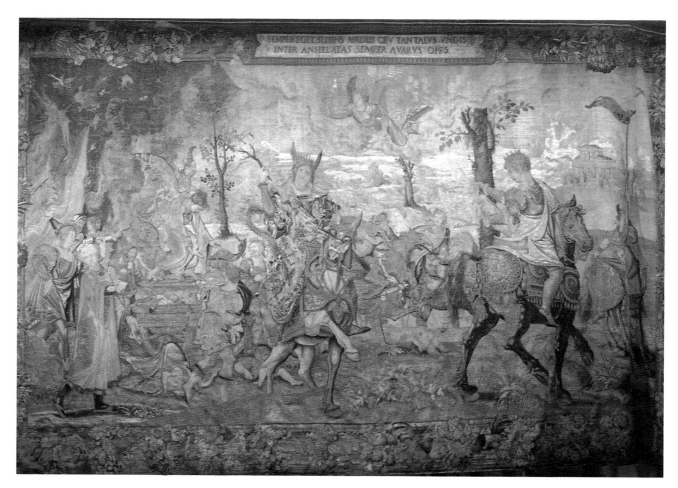

SEMPER EGET SEDENS MEDIIS CEV TANTALVS VNDIS
INTER ANHELATAS SEMPER AVARVS OPES

Plate 35, top. Avarice, *overall
view.*

Plate 36, right. Avarice, *center top, showing front mending
with warp thread laid in.*

Plate 37, above. Avarice,
*reverse, showing mending
stitches and support stitches
joining support panels.*

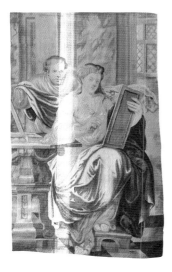

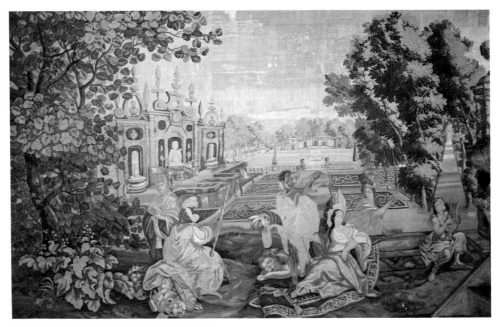

Plate 38, above. Full front view of the Cotehele tapestry, Arithmetic, *that had been previously treated with Copydex adhesive, as seen prior to conservation.*

Plate 39, right. Full view of Soho tapestry, Africa, *after conservation.*

Plate 40, right. The Gathering of the Manna, from the back, showing extensive silk loss involving no less than 75 percent of the original.

Plate 41, far right, top. Detail showing the enormous holes in the weft on the left side of the tapestry, some as large as 100 cm x 30 cm.

Plate 42, far right. Detail showing the condition of the warp.

Plate 43, below. Worktable used for attaching the lining.

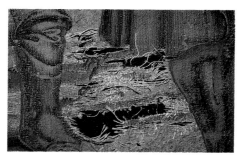

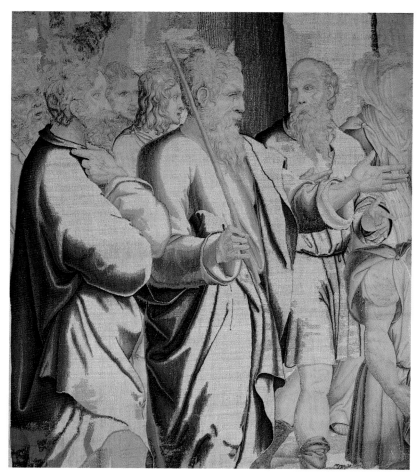

Plate 44, top. Two important figures of The Gathering of the Manna *in their restored basic colors of blue, yellow, and yellow-green.*

Plates 45, 46, above. Treatment of the holes in the warp using a custom-made wool warp.

Plate 47, top right. Overall view of The Gathering of the Manna, *after restoration.*

Plate 48, right. Leonide Steals the Letter of Astrea from the Sleeping Celadon, late sixteenth century. Scarf of Leonide shown before treatment.

Plate 49, far right. Leonide's scarf shown after treatment.

Summary of the Discussions

Liliane Masschelein-Kleiner

The seminar was organized thematically in two parts: Papers addressing embroidery treatments preceded those concerned with tapestries. Each series of individual presentations concluded with a group discussion in which the participants exchanged views, located areas of agreement, clarified differences, and proposed topics for further research. These discussions added an essential dimension to the seminar, providing an opportunity to chart our common ground and pathways for the future. We deliberately limited the number of participants in order to stimulate this crucial forum. The conclusions that follow below represent the views of the majority; they do not necessarily agree with the content of all papers.

Preliminary Studies

The great responsibility implicit in our work requires that all restorers—those at public institutions and private workshops alike—carry out a thorough examination of a textile prior to treatment. Interdisciplinary collaboration with scientists and art historians can yield the richest harvest of facts in this regard, especially when art historians and curators are aware of, and specifically trained with respect to, the technological factors in textiles conservation. This type of collaboration also benefits when restorers and their colleagues in other disciplines exercise equal influence on decisions affecting the preservation of objects. In general, this means that the role of the restorer in the overall museum hierarchy needs to be strengthened and enhanced—an objective that can best be attained by ensuring high standards for the profession and a high level of education for its members. Participants agreed that the task of strengthening professional standards and developing the profession as a whole falls within the appropriate scope of the ICOM Committee for Conservation. Furthermore, restorers should be encouraged to publish the results of their research and treatment interventions as frequently as possible, as an avenue to professional development that is within individual control.

The condition report compiled before treatment should include any historical data recorded or otherwise known about the object. This information can help to identify areas that require further research, such as certain traditional embroidery techniques about which we have very little knowledge at present. The report should also contain a precise description of the object's present condition, illustrated with photographs and sketches. These illustrations are especially important for documenting the condition of textiles, because—as often noted—useful and crucial details

often get covered over in the course of treatment, e.g., behind a support lining. Whenever possible, thread and fabric samples should be collected as reference materials for further analysis that might help to resolve such questions as why white silk often shows more severe degradation than other materials.

After this examination is complete, the restorer, curator, and scientists who have examined the nature and condition of the materials should pool their information to determine the most suitable approach for treating the textile. Aesthetic, historical, and technological data provide the basis for resolving the question whether to favor the object's original appearance or its present condition in choosing a treatment. Most often the curator makes the final decision. Nonetheless, it remains the duty of the restorer to refuse to undertake any treatment that might compromise the object's authenticity or endanger its physical condition.

Treatment

Because of the dangers posed to fragile threads and mutable dyestuffs, cleaning should be attempted only after (1) thoroughly testing the fibers, dyestuffs, metallic threads, and finishings for their fastness under the most extreme conditions of temperature and exposure and (2) carefully weighing all the factors militating for and against the procedure. If, all things considered, cleaning seems justified, suction through gauze should be the first line of approach. If more drastic measures are indicated, wet cleaning, rather than dry cleaning, should be the next choice. Water, either pure or with a small amount of neutral detergent added, dissolves many kinds of stains while relaxing creases and restoring a supple quality to the cloth. Chemical additives should be used very sparingly because they have an affinity for the fibers and tend to remain on the surface even after thorough rinsing.

The subject of consolidation sparked an unqualified consensus that adhesion by glue is not a viable approach. Past experiments with adhesives have produced results that can be described as disastrous because of the heterogeneity of the materials and because the glue adds an undesirable thickness to the textile in the areas of consolidation. Sewing is the most appropriate method of consolidating textiles. If a textile is too fragile to tolerate sewing, then solutions other than gluing should be considered: for example, "sandwiching" the textile between two linings or mounting the textile under a glass plate or in a showcase. Participants generally select natural materials over synthetics to reinforce old textiles. However, further research is still needed to evaluate the compatibility of old fibers with new fibers and of natural fibers with synthetic fibers such as nylon and polyester.

On the subject of fumigating historic textiles, participants recommended that further experiments be carried out on the use of such treatments as nitrogen, carbon dioxide, deep freezing, etc.

The clear necessity of using only the best-quality products and materials for all conservation work has raised the problem of quality control, a problem that burdens private restorers in particular. Top-quality conservation materials specially manufactured and warranted by international label are surely needed. Participants agreed that the ICOM Committee for Conservation might help spearhead an effort to address this need by soliciting international cooperation and by bringing it to the attention of specialized laboratories.

Removing old restorations can be a risky procedure because it can cause further loss of original fibers. This approach is justified only in cases where the old restorations distort the visual aesthetics of the work or where their presence jeopardizes the conservation of the original.

Reweaving the missing parts of tapestries is an appropriate treatment as long as the warps are still present in good condition and the design is readily discernible from the remaining parts. The introduction of new warps can cause the loss of origi-

nal fibers as well as undesirable stretching. For repairing large lacunae, the IRPA workshop proposed a method of sewing warps on the linen lining alone and covering it with stitches to imitate the missing design. Yvan Maes proposed innovations developed at the private workshop Gaspard De Wit to repair an almost totally ruined tapestry within the economic constraints of a commercial enterprise.

No treatment is complete without extensive documentation of each step, including a record of all discussions. Participants agreed that it would be helpful to colleagues if the restorer also noted ideas for further treatment he or she would have undertaken, given additional time and/or money. Moreover, the documentation record should include the restorer's views on what aspects of the treatment did not succeed and why they did not.

Display and Storage

Display arrangements for textiles should be such as to allow viewers to see the object without touching it—e.g., display cases, barrier rails, etc. Attention to the construction of storage cases and showcases is necessary to ensure that they are made of appropriate materials, that is, materials that are not somehow harmful to the textiles they are meant to protect. Well-constructed display and storage cases should, in fact, provide a buffer against fluctuations in ambient humidity. Tapestries should be displayed against internal walls only, ideally at a slight distance from the wall to allow for good air circulation. Some sort of covering should be provided to prevent dirt from accumulating along the tapestry's upper edge.

Conclusions

The conclusions expressed here reflect only the content of the discussions and not their intense and spirited nature, which carried the talks well over their allotted time. These discussions provided a rare opportunity for members of this widely dispersed community to intersect methods, philosophies, successes and failures, innovations, and the limitations each specialist has to contend with and overcome. The differences between specialists in private practice and those working in public institutions rang loudest of all. And yet, through the exposure of these differences in an open forum, a new awareness emerged that transformed those differences into mutual appreciation of the advantages and limitations inherent in each sphere of conservation work.

Biography

Liliane Masschelein-Kleiner has served as director of the Institut Royal du Patrimoine Artistique since 1984 while also heading the organization's Scientific Research department. A native of Brussels, she received her Ph.D. from the Université Libre de Bruxelles in 1963. Her research focuses principally on the fields of natural film-forming substances, ancient and modern dyestuffs, solvents, and the conservation of textiles. She has lectured and taught courses on these subjects at IRPA and internationally.

The Conservation of Embroideries at the Institut Royal du Patrimoine Artistique

Juliette De boeck, Vera Vereecken, and Tatiana Reicher

The Altar Frontal from Middelburg

Embroideries were one of the most sumptuous kinds of textiles produced in sixteenth-century Europe, and among these costly goods, gold embroideries were the most precious. The altar frontal of Grimbergen-Nassau, an important example of gold embroidery belonging to the Musées royaux d'Art et d'Histoire in Brussels, was entrusted to our textile workshop for treatment.

This altar frontal, or antependium (Fig. 1), which measures 93 centimeters x 377 centimeters, was recently identified by E. Dhanens (1985:107–117) as coming from the former abbey of Middelburg in Zeeland. Dhanens dates the antependium from circa 1518.

The antependium shows, from left to right, the wedding at Cana, Jesus in the house of Simon, the Last Supper, Jesus in the house of Levi, and the pilgrims at Emmaüs. These five scenes are framed by embroidered Renaissance arches and columns. The columns are embroidered in high relief on separate linen linings filled with rags. Two half-columns (lengthwise) flank the design on each side. The antependium is bordered on three sides (upper and lateral) by a gold strip approximately 4.5 centimeters wide, sewn in couching technique and slightly embossed.

Preliminary Examination

The embroidery was extremely fragile. The gold threads, laid two by two, were partially covered by colored silk wefts; the wefts were missing in several places. It was urgent to fix these heavy gold threads in order to avoid further damage to the silk wefts. Most of the embroidery was worked using laid and couching technique.

Figure 1. The altar frontal from Middelburg after treatment.

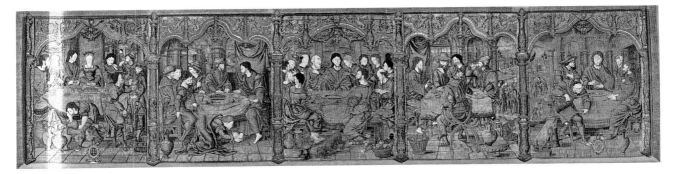

Figure 2, right. The scene depicting the wedding at Cana before treatment.

Figure 3, top. A face sketched on the linen, shown before treatment.

Figure 4, above. A face embroidered onto a separate overlay.

The silk threads of the weft are not twisted. In this laidwork the stitches crossing the gold warp at right angles are spaced in a pattern to create the shades of light and shadow. Other embroidery techniques include filling stitches for flesh tones and hair texture and cross stitches of silver threads for the fringe of tablecloths and for some clothes. Rich metallic gold and silver twisted threads underline many details.

The metal threads were analyzed by X-ray fluorescence. The gold threads are made of a silver strip 170 μ wide by 10 μ thick (86.6% silver, 11.3% iron), gilded on the upper side. The silver threads are made of a silver/copper alloy (90/10% to 88/12%); the band is 250–300 μ wide by 20–30 μ thick. This metal band is coiled around an S-twisted silk core. The support consists of two layers of heavily starched linen (Z-twist) fabric in plain weave.

The scene depicting the wedding at Cana (Fig. 2) shows certain technical peculiarities. For example, the first row of tiles in the pavement was added after the original embroidery, probably to accommodate the height of the altar. Also, unlike the other scenes, two faces in this scene are embroidered directly onto the lining (Pl. 1). All of the other faces were sketched in on the linen and embroidered onto separate overlays (Figs. 3,4). The outlines of the separate heads were sewn onto the embroidery with brown silk thread in light and dark shading. Many faces had retained only a few traces of this fine outlining. Nineteenth-century restorers reinforced these outlines with black string. We removed this heavy-handed repair. X-radiographs showed that no metal threads were present beneath any of the faces or beneath the columns.

Treatment

The antependium was disassembled into its component parts: the framing strip, the columns, and the five panels. Each panel was gently stretched on an embroidery frame by means of linen borders sewn at the upper and lower edges. The conservation treatment focused on anchoring the loose gold threads (Fig. 5).

As per our usual practice, we did not reconstruct lost parts that could not be deduced from the remaining design. It was decided to couch the laid gold warps with perpendicular silk stitches at regular intervals.

Figure 5, above. Securing the gold threads with couching stitches, as shown during treatment.

Figure 6, right. Restoration of missing outlines, after treatment.

The best effect was obtained by using untwisted silk threads dyed in a hue similar to gold. The dyestuffs (premetallized acid dyes) are colorfast with respect to light and washing. This work required meticulous attention in order to maintain an even pattern of stitches. The bright reflection of the gold threads was tiring for the eyes. The missing outlines were restored using eight threads of untwisted brown silk worked with a single thread in the laid and couching technique (Fig. 6). Some weak areas of the support were consolidated by attaching a linen lining.

Many of the silk filling stitches in the areas of the hands and feet were worn out or destroyed, leaving the gold threads visible underneath. Only in these areas did we allow a few stitches with double-thread silk, following the direction of the embroidery and at the same time anchoring the loose gold threads. The loosened fringes of the altar cloth were secured at the bottom with untwisted silk and in the middle with a forestitch.

After completing the treatment of the five panels, we reattached the panels to one another with linen strips sewn in a zigzag stitch behind the columns on the back of the embroidery. The columns were sewn into place with Gütermann's silk. The framing strip was sewn in the same way. Missing portions were completed with a linen strip of similar size and color, filled with linen and Vliseline. By superimposing layers, each a bit narrower than the previous one, we created a curved effect. A new wooden stretcher was fashioned after the former model and covered with a preshrunk linen fabric clamped into place. The antependium was then sewn onto this fabric with silk threads in straight lines 45 centimeters long, overlapping and spaced at a distance of 15 centimeters. Shorter lines of stitches were sewn every 7.5 centimeters at the top. The altar frontal, framed and mounted behind glass, is now exhibited in the museum.

The Altar Frontal from Herkenrode

The altar frontal from Herkenrode was bought in 1911 by the Musées royaux d'Art et d'Histoire. Mathilde de Lechy, Abbess of Herkenrode, ordered it in 1528 from the Antwerp embroiderer Paulus van Malsen. It shows the Last Supper flanked by the symbolic figures of the Synagogue on the left and the Church on the right. These gold embroideries were appliquéed on an Italian Bordeaux velvet with a pomegranate motif. They were removed from this support during a previous restoration and transferred separately onto a blue lining (Pl. 2). The museum's present curator, Dr. Guy Delmarcel, found out from the archives that the original support was red velvet. Then, in the workshop where we previously stored important old linings, we redis-covered the original velvet, bearing the marks of the appliqué figures on it. It was decided to restore the cloth to its former appearance.

Figure 7. The reverse side of
the original Bordeaux velvet
fabric before treatment.

Preliminary Examination

The embroideries had been worked using the same technique that was used in the antependium from Middelburg—laid and couching and filling stitches—but using thinner gold threads on a double linen (Z-twist) fabric in plain weave. Some gold threads were loose, mainly in the central part of the Last Supper, and most of the areas embroidered with filling stitches were worn out.

The Bordeaux velvet fabric is made of silk in satin weave. It was divided into four pieces (Fig. 7). The one on the extreme right was still sewn to the adjacent piece with the original stitches. The others (except for the piece on the right) still showed their selvages, which proved that the original weaving width was 57 centimeters. The central panel had been cut along the outline of the lower half of the Last Supper embroidery. The velvet shows nail holes every 4 centimeters along its borders, as well as stains from glue, starch, and paraffin.

Treatment

The stains on the velvet were eliminated mechanically under the microscope, and the threads from old stitches were removed. The fabric was then carefully vacuum-cleaned through gauze. The lower half of the central section was consolidated onto a linen fabric, using a silk two-filament yarn (needle no. 12) and span stitches. The damaged areas were consolidated in the same way. The three separate pieces of velvet were sewn back together following the traces of the original stitches. The damaged borders were lined with Bordeaux linen.

The embroideries were then carefully detached from their blue lining. Some pearls were found on the socle of the Church. The embroideries were originally richly decorated with such pearls, as documented in the original purchase order and evidenced by the remaining securing threads visible on the reverse side, the little hollows in the support fabric, and the deformations of some threads (Fig. 8). Twenty-two of these pearls still remain under the crown around the Last Supper (Fig. 9). The gold threads were anchored with silk yarn dyed to match. Finally, the embroideries were sewn to the velvet, using the holes of the original stitches. The whole was attached to a preshrunk linen fabric clamped to a wooden stretcher (Fig. 10).

Figure 8. Reverse side of the
embroidery showing the
threads anchoring the pearls.

References

Dhanens, E.

1985 *Academiae Analecta.* Mededlingen van de Koninklijke Academie voor Wetenschappen, Letteren en Schone Kunsten van België, Klasse der Schone Kunsten. 46:1.

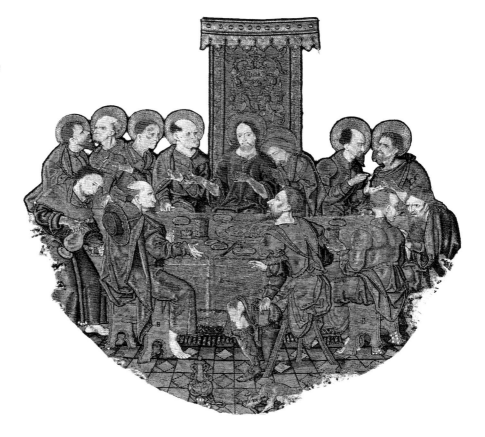

Figure 9. Detail showing some of the pearls remaining under the crown.

Figure 10. The altar frontal from Herkenrode after treatment.

Biographies

Juliette De boeck, a native of Belgium, heads the textile workshop at the Institut Royal du Patrimoine Artistique where she was trained in textile conservation under Dr. Masschelein-Kleiner. Her published papers document some of the projects undertaken by the workshop since she assumed her position in 1977.

Vera Vereecken has served as assistant conservator at the IRPA textile workshop since 1977.

Tatiana Reicher joined the IRPA textile workshop in 1985. She was born in Russia and received her education in Poland. Since 1968 she has been living in Belgium.

The Restoration of the Antependium of the Musée Paul Dupuy in Toulouse

Mechthild Flury-Lemberg

The Toulouse antependium, an important example of medieval embroidery, was sent to the workshop of the Abegg Foundation for conservation in 1984 after our sponsor, Werner Abegg, saw the work on a chance visit to the Musée Paul Dupuy.

There was nothing to indicate how difficult this undertaking would turn out to be. At a cursory glance, the antependium, crudely worked in gold and silver, gave the impression of an *opus anglicanum*. The truth of the matter was quite different. As we soon found out, the original silk embroidery had been almost completely covered over when the piece was reworked in the nineteenth century. Except for the gold embroidery and a few sections of the silk, none of the original threads were visible. This later work was clearly inferior to the original. Moreover, the original lines, colors, and even to some extent the iconography had not been treated with due respect. The overall palette of the reembroidered work was gold to beige, with a few blue touches. At the right edge, where the altar cloth had been cut unevenly, the heads of a group of figures had escaped oversewing, allowing us to compare the original with the restoration. Although the silk stitching of their faces had fallen out, the expressive outlines and the exquisitely detailed embroidery of the hair clearly demonstrated the difference between the two works (Pl. 3). The original proved to be a work of very high standard, dating from the thirteenth century.

It is rare to find embroidered works of art from the Middle Ages that have not been subjected to repair of one sort or another. The more highly a work was valued, the greater were the efforts made to preserve it. The question of whether to leave or to remove these "historic" restorations can be decided only on a case-by-case basis. The nineteenth-century restorers who reworked the Toulouse antependium made an extraordinarily thorough effort to retain the altar cloth's original appearance, indicating that they considered the piece especially precious. Their thorough work left us to face a few questions. What did the original look like before restoration? Why did the restorers cover over the original so completely? Had the original silk embroidery become brittle and fallen out altogether? Or had it been worn away in parts in a way that diminished its visual impact, especially when viewed from a distance by a congregation? In essence, what would we find if we were to remove the restoration?

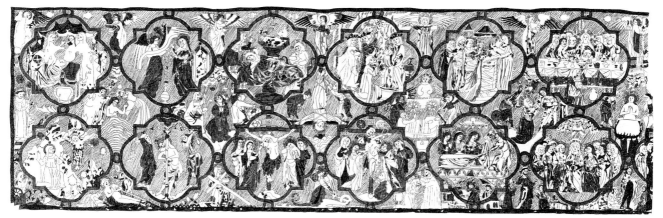

Figure 1. Drawing of the antependium before its restoration, showing the findings of the preliminary examination: areas where the original gold and silk embroidery remained visible; areas where the original embroidery definitely remained, though hidden beneath the overstitching; and areas where the presence of the original embroidery could not be determined.

Figure 2, top. Detail of the antependium prior to restoration, showing the coarse overstitching.

Figure 3, above. The same section as shown in Fig. 2, after uncovering the thirteenth century embroidery work.

Figure 4, right. The presentation in the temple. On the left, the undifferentiated nineteenth-century embroidery; on the right, the drawing of the detailed thirteenth-century embroidery.

We began with extensive tests conducted over a period of weeks to determine how much of the original embroidery had been preserved beneath the new stitching. The results of these tests provided a detailed blueprint (Fig. 1) and a basis for deciding whether to expose the medieval work of art, removing the nineteenth-century restoration, or to respect the effects of history on the object by leaving the original invisible and hence unknown.

Our test showed that the light shades of silk used for the flesh colors and white parts of the original had suffered the greatest losses. This came as a surprise, since our experience with medieval textiles has shown that it is usually the dark colors that are destroyed. (We speculated that perhaps the natural silk of the original had not been degummed, which could explain this unusual development.) Despite these losses, even where the embroidery is missing altogether, well-defined outlines traced on the linen background remained visible. From the few areas that were exposed, we could see the exceptional subtlety of the medieval embroidery. It was also evident that the restoration work had failed to capture the subtle colors and magnificent design of the original. The later stitchwork offered fewer details, as it was executed somewhat more crudely than the original (Figs. 2,3). We could also see that the restorers had misinterpreted individual details, even to the point of altering the original significance of many of the scenes (Fig. 4). As a final consideration, the silk used for overstitching was itself in bad condition. Years of overexposure to light had damaged not only the colors but also the condition of the thread, making it so brittle that it crumbled at the slightest touch. All of these factors weighed in our decision to uncover the medieval embroidery, especially as our tests had shown that much of the original would be revealed.

It should be added here that in its existing state, the antependium could not be considered a nineteenth-century work of art, nor was it a thirteenth-century work.

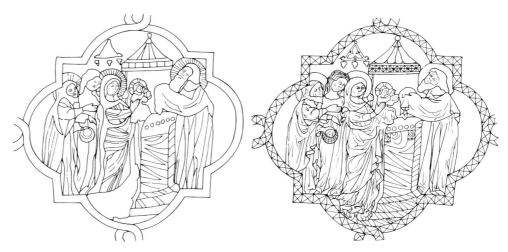

Figure 5. Arrangement of
scenes on the embroidered ante-
pendium. Top row: angels, the
fifth from the left seen full-
face. Second row: (a) the birth
of the Virgin, (b) the Annuncia-
tion, (c) the Nativity, (d) the
adoration of the Magi, (e) the
presentation in the temple,
(f) the Last Supper, (g) the
betrayal (?), (h) Christ before
Pilate (?). Middle row: (i) Saint
Francis preaching to the birds,
(j) the baptism of Christ,
(k) the stoning of Saint
Stephen, (l) the crucifixion of
Saint Peter, (m) Saint Francis
on the fiery chariot, (n) the
beheading of Saint Paul,
(o) John the Baptist in the caul-
dron (?), (p) the death of Saint
Francis (?). Fourth row: (q) the
stigmatization of Saint
Francis, (r) the flagellation of
Christ, (s) the Crucifixion,
(t) the deposition from the
cross, (u) the three women at
the tomb, (v) the Ascension,
(w) the Pentecost (?), (x) the
coronation of the Virgin (?).
Bottom row: (y) Saint
Catherine, (z) Saint Lawrence,
(aa) Saint Philip, (bb) Saint
Michael, (cc) Saint Clare and
Saint Francis, (dd) Saint James
the Greater, (ee) Saint
Bartholomew(?), (ff) Saint
Clare (?).

It could be regarded only as a documentary example of restoration, one that was already advanced in the process of decay. Even in such a state it was certainly worthy of note; yet we felt that its significance as a document could not compare to the significance of the medieval work concealed beneath the treatment.

After extensive photographic documentation, we began carefully uncovering the thirteenth-century work, centimeter by centimeter. We left the nineteenth-century embroidery on the figure of Saint Catherine at the bottom left-hand corner of the cloth as testimony to the history of the work. Once the restoration had been removed, we were able to wash the antependium to revive the gold areas as well as the silk. Using fine silk threads, we anchored the damaged parts to a backing fabric and mounted the altar cloth under glass.

The original work turned out to be a masterpiece of western stitchcraft. Where the embroidery is missing, beautifully drawn outlines remain so that the losses are not perceived as gaps. These outlines are of considerable interest in their own right.

Also, thanks to the overstitching, the finely detailed silk embroidery work has retained its vibrant colors, as we can see by comparing it to the back of the cloth. Moreover, the work is in excellent condition. The silk shows no trace of brittleness. These results exceeded our expectations. Despite some damage, the altar cloth in its original condition remains an outstandingly expressive work of art.

The iconography of the antependium is unusual in that scenes from the life of Christ are interwoven with scenes from the life of his follower Saint Francis of Assisi, as recorded by Saint Bonaventure (Fig. 5; Ruf 1981a). Both rows of quatrefoils and their gyrons present these scenes, along with the lives of other saints. The depiction of Saint Francis being borne up to heaven on a fiery chariot by two angels indicates the original center of the antependium, before the right edge was lost. In the gyron above this scene, an angel appears in frontal view to emphasize its significance. The remaining gyrons of the upper row depict angels in left and right profile flanking the central image. At the lower edge of the center gyron, there is a depiction of Saint Francis initiating Saint Clare into the order by personally cutting off her hair. Such a representation of the saint is extremely rare, not to be found even in Assisi. Of course, scenes featuring Saint Clare are few in any case. The fact that she appears in a central scene suggests that the embroidery might have been sewn in a convent of the Clare order or that the antependium was intended for the order's use.

Two other scenes depict Saint Francis. The middle row of gyrons (featuring the chariot scene in the center) begins with the scene of Saint Francis preaching to the birds, a standard rendering in any Franciscan cycle. The lower row of quatrefoils begins with the scene of the stigmatization of Saint Francis, followed by the castigation of Jesus, the Crucifixion, and the removal of Christ from the cross. In other words, the portrayal of Saint Francis receiving his stigmata precedes the passion section of the altar cloth, thus illustrating one of the main tenets of the Franciscan

order, namely, that Saint Francis is regarded as a successor to Christ. The sequence continues to the right with depictions of the three major joyous feasts of the Christian calendar: Easter (the three women visiting the empty tomb); the Ascension (the Virgin Mary surrounded by the disciples); and Whitsun (the Holy Spirit descending on the apostles). Most of this last scene is missing. Since the altar cloth probably belonged to a convent, we can speculate that a scene of Mary's coronation may have followed the Whitsun scene. Many late thirteenth- and early fourteenth-century embroideries present her coronation as the culmination of the story of salvation.[1]

The upper row of quatrefoils begins with the scene of Mary's birth, followed by the Annunciation, the birth of Christ, the adoration of the Magi, the presentation in the temple, and the Last Supper. Two scenes are missing on the right. The traditional sequence, as found in the upper church of the Basilica of Saint Francis in Assisi, for example, would continue the story of Christ's passion with scenes of Judas betraying Christ and Christ before Pontius Pilate (Ruf 1981b). Both scenes figure in the above-mentioned examples of embroidery.[2]

The sequence of scenes in the middle row of the altar cloth—flanking the scene of Saint Francis on the fiery chariot—primarily portrays martyrs suffering the baptism of blood that corresponds to Christ's Crucifixion. Francis preaching to the birds is followed by Christ's baptism, then the stoning of Saint Stephen, the crucifixion of Saint Peter, Saint Francis on the chariot, the beheading of Saint Paul, and John the Baptist in the cauldron. The thematic thread of this sequence suggests that the two missing gyrons might have depicted the death of Saint Francis and another "blood testimony" of someone who became Christ's successor through his death.

The lower row of gyrons begins with a depiction of Saint Catherine, a female saint, and continues with Saint Lawrence, Saint Philip, and Saint Michael. Saint Francis and Saint Clare occupy the central position, followed by Saint James the Greater and Saint Bartholomew. Following the above line of thinking, we could expect that the two missing gyrons would depict another male saint and Saint Clare at the end of the row.

The emphasis on scenes from the life of Saint Francis leaves no doubt as to the identity of the group for which this antependium was made. The young Franciscan order was extremely active around Toulouse in the thirteenth century, with monasteries having many members. Following the example of their founder, the Franciscans observed the law of poverty as applied to the individual, not to the order itself. By the thirteenth century, the Franciscan communities had in fact become quite rich and were certainly in a position to commission costly works of art to glorify God and their founder, Saint Francis. The convents did not generally share in the wealth. They remained small and poor by comparison. Still, it is quite plausible that the "poor sisters" came to own the antependium, perhaps through the help of a benefactor. The depiction of the ordination of Saint Clare lends weight to this theory. It provides the focal point of the composition and refers to the investiture ceremony, one of the significant events in a nun's life.

Now that the antependium has been restored to its original appearance, it stands as an example of medieval textile art that is unique for its artistic design as well as for its technical execution and iconography (Pl. 4). An examination of the compositional detail—the rendering of the cross and of Saint Peter being removed from the cross in the scene of his crucifixion, for example—confirms this judgment. The exposure of the original embroidery revealed an excellent work of French origin modeled on thirteenth-century French manuscripts and stained-glass windows—not at all the *opus anglicanum* suggested at initial glance by the arrangement of quatrefoils

in rows. With the restoration of the medieval embroidery, the Toulouse antependium has transcended its previous claim as an object for iconographic study and come fully into its own as a work of art (Brel-Bordaz 1982:166).

Notes

1. Renate Kross, *Niedersächsische Bildstickereien des Mittelalters* (Berlin1970). Among these examples, no. 16 (circa 1300) depicts the joys of Mary, viz. the Annunciation, the birth of Jesus, the adoration of the Magi, the presentation in the temple, the coronation of Mary. No. 97 (circa 1350–1360) offers all of the scenes found on the Toulouse antependium plus an additional twenty-five scenes. Here, too, Mary's coronation follows the Whitsun scene. Antependium no. 19 (1330) places Mary's death between the Whitsun scene and her coronation (a new theme, according to Kross). No. 55 (circa 1260) shows a large-scale representation of the crowning of Mary, with saints. No. 92, an altar cover (circa 1330–1350), displays the same scenes as the Toulouse antependium except for the passion scenes (Annunciation, birth, presentation in the temple, Resurrection, Ascension, Whitsun, and Mary's coronation), which are instead combined in the Throne of Mercy.

2. See note 1.

References

Brel-Bordaz, Odile
1982 *Broderies d'ornements liturgiques XII–XIV siècle, opus anglicanum.* Paris: Nouvelles Editions Latines.

Flury-Lemberg, Mechthild
1988 *Textile Conservation and Research.* Vol. VII. Bern: Schriften der Abegg-Stiftung.

Kross, Renate
1970 *Niedersächsische Bildstickereien des Mittelalters.* Berlin: Deutscher Verlag für Kunstwissenschaft.

Ruf, Gerhard
1981a *Franziskus und Bonaventura.* Assisi: Casa editrice francescana.
1981b *Das Grab des heiligen Franziskus.* Freiburg i. B.: Herder.

Biography

Mechthild Flury-Lemberg has served as head of the Textile department of the Abegg Foundation, Bern, since 1963. A native of Hamburg, she moved to Switzerland to become curator of textiles at the Historical Museum in Bern after receiving her education in Germany.

The Burgundian Vestments

Rotraud Bauer

The recently reopened Schatzkammer in Vienna offers a new and attractive display of the Burgundian vestments of the Order of the Golden Fleece, exhibited under optimal conditions of lighting, temperature, and humidity control (Pl. 5). This magnificent ensemble, dating from the second quarter of the fifteenth century, consists of three copes, one chasuble, one tunic, one dalmatic, and two antependia. They are regarded as the world's most precious paraments. Their distinction lies not only in the fact that a so-called *chapelle* is preserved here in its entirety, but also in the unusual artistic splendor of the set, as emphasized by the new display. Except for the faces, hair, and fur trimming, the entire design is embroidered over gold threads that radiate an almost supernatural brilliance. Moreover, the rich, warm reflection of colorful silk threads presents a fascinating picture. Thousands of little pearls strung in rows or concentrated in rosettes add to the extraordinarily precious character of this set.

The fact that the paraments do not bear the emblems of the order—flint and steel—has led us to think that they were not originally commissioned for the order but rather for private use by Philip the Good of Burgundy. They may have come into the possession of the order after Philip's death in 1467. In any case, from 1477 onward the Burgundian vestments are registered in the inventories of the Order of the Golden Fleece.

The work is distinctive not only for its impressive needlework (more about that below), but also for its design. The quality of the drawings suggests the work of some of the famous early Netherlandish painters such as Hubert van Eyck (circa 1370–1426), Jan van Eyck (circa 1390–1441), or the Master of Flemalle, sometimes identified as Robert Campin (1375–1444). One of Campin's pupils, Rogier van der Weyden (circa 1400–1464), seems to have executed some designs for these paraments—the angels at the chasuble, for example—at the beginning of his career.

The two antependia rank as the oldest constituents of the ensemble. On each cloth, six apostles and six prophets arranged in two rows flank a central scene. The frontal antependium features a central scene of the Virgin enthroned, with John the Baptist and Saint Catherine receiving the ring of the mystic marriage from the baby Jesus. The center of the other antependium displays an image of the so-called *Gnadenstuhl*, or Throne of Mercy, a version of the Trinity in which God the Father holds the body of his dead son aloft (Fig. 1). Between their two heads the Holy Spirit appears in

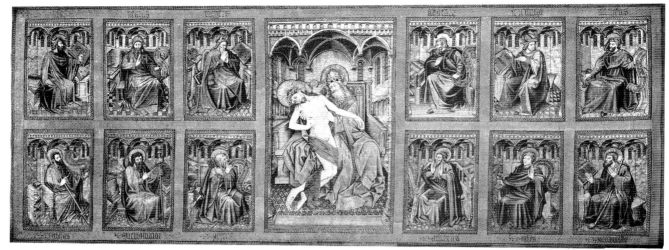

Figure 1, above. Antependium with the Gnadenstuhl *(Throne of Mercy), prophets, and apostles (inv. Pl 18).*

Figure 2, right. Cope of Christ, displaying the omnipotent God on the hood, apostles and prophets on the orphrey band, three rows of cherubim with Archangel Michael, saints, male martyrs, holy sovereigns, and clergymen (inv. Pl 19).

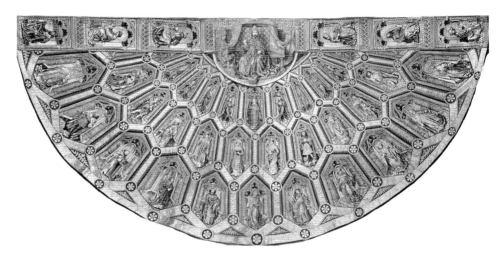

Figure 3, right. Tunic showing angels on the orphrey bands and three rows of female saints (inv. Pl 15).

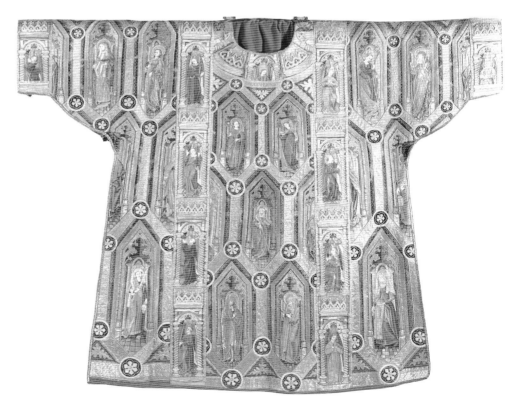

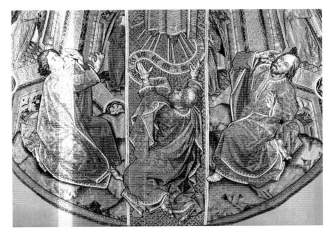

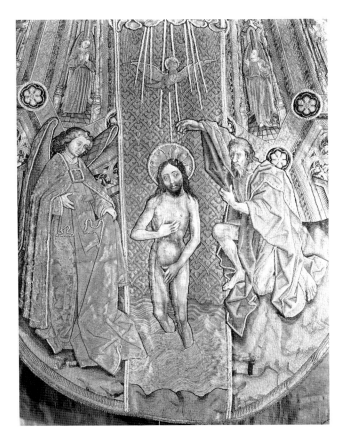

Figure 4, right. Chasuble, detail of the front showing the baptism of Christ. Note the missing pearls, especially in the vertical lines (inv. Pl 14).

Figure 5, above. Chasuble, detail of the back showing the Trans-figuration.

the form of a dove. This treatment of the Holy Trinity is also found in the works of the Master of Flemalle, and it therefore seems likely that he designed this scene for the embroidery with his own hand. The three copes taken together illustrate the theme of All Saints.

The central shields or hoods present the omnipotent God in the middle, with Mary and John the Baptist on either side. The cope of Mary displays angels, female saints, and holy virgins and widows in three rows. The cope of Christ (Fig. 2) and the cope of John display angels, male martyrs, saints, holy sovereigns, prophets and priests, monks and hermits in three rows. The overall concept executed in these three copes closely parallels that of the Ghent altarpiece by Hubert and Jan van Eyck, completed in 1432.

The chasuble, dalmatic, and tunic (Fig. 3) were made a few years later than the antependia and copes. The dalmatic worn by the deacon and the tunic worn by the subdeacon also display three rows of saints—male saints on the dalmatic, female saints on the tunic—in elongated hexagonal fields arranged in honeycomb fashion. Orphrey bands and apparel decorated with delicately rendered angels suggest the work of Rogier van der Weyden.

The honeycomb arrangement of three rows of figures also occurs on the chasuble. The chasuble's featured images are the baptism of Christ on the front (Fig. 4) and the Transfiguration on the back (Fig. 5). The orphrey bands, the cross, the three apostles, the angel, and John the Baptist were embroidered separately and sewn into place.

The embroideries are worked on a sturdy linen cloth. Unfortunately, we cannot see the reverse side because it is covered by a pink linen lining, probably the original (Pl. 6). A network of restoration stitches, especially in the areas of the seams, attaches the lining to the base fabric in a way that prevents us from seeing underneath.

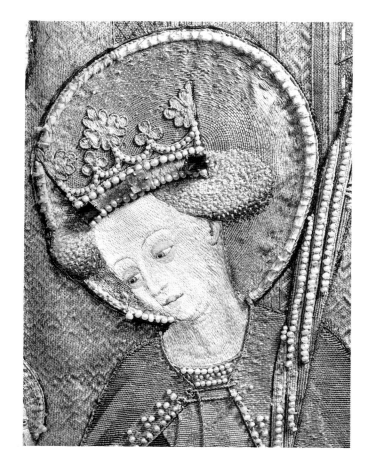

Figure 6. Antependium with the "mystic marriage" detail of Saint Catherine, showing an example of needle painting technique. Note the missing pearls in the halo. On the left side a pearl is coming loose. Pearls are anchored on top of a bundle of linen threads. Where pearls are missing, the remains of securing stitches are visible. Note also how light and shadow are modulated by the placement of stitches on the lips and eyes (inv. Pl 17).

Figure 7. Cope of John the Baptist, detail showing a prophet in his niche. Note the loose gold threads in the or nué parts where the couching silk threads have been torn or fallen out.

Aside from the scenes on the chasuble and the orphrey bands, the only other appliqués occur on the antependia. The seated prophets and apostles and the figures of the two central scenes were embroidered separately, then sewn directly onto the bare linen, as seen in Figure 1.

Red velvet ribbons and blue velvet disks are also appliquéed; the disks provide a background for pearl rosettes (Pl. 7). The gold braids that were thought to be appliqués turned out to be laidwork of gold thread lightly couched with silk. At some point these silk threads began to break. In order to prevent the gold threads from coming loose, another net of gold laidwork couched with silk was superimposed on the original threads. These couching stitches are visible on the pink linen that lines the reverse side of the embroidery, as seen in Plate 6. We have no record of this crudely executed treatment, which indicates that it must have been performed quite long ago. The only places where the original gold laidwork is preserved are on the three copes, in the areas protected beneath the hoods.

Two embroidery techniques embellish these vestments. The first is the so-called "needle painting," worked exclusively with silk threads to render bare skin and hair in a skillful interplay of light and shadow, as we can see on the eyelids in Figure 6. The stitches actually imitate brushstrokes in the attempt to simulate the appearance of painting. For this technique, an extremely subtle range of silk threads modulates the shades. Even in so small an area as the eyes, for example, we find as many as three different shades: blue, black, and plum blue.

The second technique is *Lazurtechnik*, also called *or nué* (Pl. 8). Parallel gold threads are laid flat on the surface of the cloth and couched with silk stitches. Shading is created by the density of these couching stitches—close together for the dark shades, further apart for highlights and reflected light. In the delicate parts of the design, each stitch passes over every two gold threads (Pl. 9); in other areas, such as

The Burgundian Vestments

the inner side of the dresses or on the undergarments, each stitch passes over three gold threads.

It is interesting to note that the laid gold threads are arranged not only in the usual horizontal pattern, but also vertically to enhance the feeling of space. Other effects lend a feeling of plasticity: Some of the columns and tracery on the little niches are sewn in relief technique (Pl. 7). The pearls, the cut-glass stones (Fig. 6), and the body of the dove (Pl. 13), which is filled with threads and molded three-dimensionally, also enhance this impression. The laidwork does not always follow a straight pattern of stitching; it can also follow the shape of the design, as in the waves of the Jordan River (Fig. 4) or in Moses' cap. The impact of these special effects depends largely on the lighting.

Preservation

Having described the beauty of these paraments, I will now turn to the issue of their preservation. At first glance, and even on closer inspection, the ensemble seems to be in excellent condition. The only apparent damage is that many pearls are missing. I will give an example to illustrate the danger that threatens these pearls: The pearls are strung on a double silk thread. This strand is positioned according to the design on a bundle of linen threads and is secured with a silk stitch after each pearl (Fig. 6). Once these silk threads break, each tiny movement of the object loosens the pearls, and one by one they vanish. They are so small that it is almost impossible to find them once they fall onto the floor or carpet.

In the case of antique textiles it is almost always the dark-brown threads that fall out, usually those used for outlining the design. The missing outlines cause more of an aesthetic problem than one of damage to the substance of the embroidery. Far greater problems are presented by the *or nué* areas where the silk shading has torn and fallen out, leaving the gold threads loose. Loss of this shading destroys the illusion of perspective, especially in the background of the niches (Fig. 7). Moreover, it is risky to handle the object in this condition because the loose threads can easily get caught or tangled.

In the areas where the needle painting has worn away (e.g., in the faces), we can see some sparse outlines of the original drawing exposed on the linen (Pl. 10). In some places only a few stitches remain; these little remainders of broken threads stick in place in the linen base only out of "habit," not because they are secured in any way. We found that in the needle painting areas, the linen base was covered with a very delicate silk material similar to crepeline. The embroiderers must have thought that the little needle painting stitches would be more shapely and easier to set against a finely structured base than against the gross texture of linen.

Figure 8. Label on the back of one antependium.

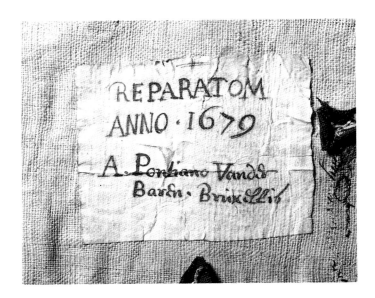

Previous Repairs

The earliest treatment of which we have evidence (Fig. 8) was performed by A. Pontinus van der Baren in 1679 in Brussels, where the paraments were kept until the 1790s. By about 1800 they were transferred to Vienna for safekeeping from Napoleon's armies. A much later treatment in 1950 included securing the pearls, couching the loose gold threads, and restitching the appliqués to the linen base wherever necessary.

We cannot ascertain the dates of some of the old repairs. They nonetheless stand out quite noticeably because their white and yellow silk threads are too thick and their stitches are crudely executed compared to the originals (Pl. 11). Couching stitches intended to secure the loose gold threads likewise stand out because of their thick threads and disorderly arrangement (Pl. 12). They were not even effective in the long run, as some of the gold threads have since come loose again.

Through the centuries, the pearls were anchored over and over many times, as we can see by looking at the back of the embroidery shown in Plate 6. The repair stitches were sewn right through the lining. At some undetermined time the loose gold threads of the so-called "braids" were repaired, as mentioned, along with the dark-brown outlines.

We know somewhat more about the restoration of the chasuble that was completed twenty years ago. At that time it was still not the usual practice to document the treatment. Nonetheless, we have a few pages summarizing the procedures, but there are no accompanying photographs. Still, from these documents we can tell which areas were treated.

Many of the dark outlines were restitched, but the flesh areas—the body of Christ in the baptism scene with its delicate shadows shaded with green and brown, for example—were left untouched. Most of the pearls were restrung to guarantee that they would be absolutely safe from loss. We still regard it as senseless to secure only those pearls that are loose at the moment, leaving others to loosen and get lost at a later time.

Twenty years ago the dominant approach was to add whatever was missing "only if the right material in the right color is available," as stated in the words of the summary report. If the right material was not available, the damaged area was protected from further ruin by anchoring the loose gold threads with neutral-colored silk, and it was left at that.

In the mantle of the angel assisting the baptism, many stitches were replaced with different shades of blue silk. Also, in some cases the pattern of the gold leaves was reconstructed, with the help of the remains of the original silk threads. Although most of the clear silk was missing from the mantle of Christ in the Transfiguration, the design of the folds was still perceptible, and, in the words of the restorers, "We tried to set each stitch exactly where it was missing."

The light- and dark-blue stitches in the blue mantle of one of the apostles in this same scene were reworked, along with the red stitches of his underclothing and the green of the angel's dress. A new dark-brown outline was sewn around his eyes, hair, beard, and hand.

The body of the dove was also reworked to some extent (Pl. 13). Almost all of the silver threads had come loose; some were missing altogether. These were replaced, and all silver threads—old and new alike—were couched down with fresh stitches. New dark-brown outlines were added to the image of God the Father (Pl. 14). Of the words in the inscription, only _hic_ remained in perfect condition; almost all of the vertical lines of the other letters had to be reembroidered.

All of this work was performed twenty years ago. Of course, today we would not go about it in the same way. Now our concern extends to damage that could occur in moving the objects. Thus, when we recently transported the copes to the

new Schatzkammer, we kept them perfectly horizontal throughout the process and slipped them very carefully from their wooden display plates onto the new ones without bending a fiber.

After completing the conservation of the coronation vestments of the Holy Roman Empire—the project that has occupied us for the last six years—we will begin working on the Burgundian vestments piece by piece. The question is: How much, or rather, how little, should be done?

Conservation Plan

The first step, after detailed examination of the object and complete documentation, must be to secure the pearls. Total cleaning should not be attempted. The pearls will recover their gleam in the course of being restrung and sewn to the embroidery. Well-preserved parts elsewhere on the embroidery might tolerate the attention of a small vacuum cleaner as used for optical instruments, but even that is questionable. Superficial dust comes off anyway onto the fingers of conservation workers handling the object during treatment, and vacuum cleaning would tend to remove the remains of broken original threads that are simply sticking to the linen. Why should we risk the complete loss of these delicate remains?

As far as we are concerned, these vestments will not move from the Schatzkammer again for any reason. (Some of our colleagues are aware of the battle we waged against the Austrian and Belgian politicians who wanted to send the paraments to the Europalia Exhibition of the Golden Fleece in Brussels in 1987.) The conservation work itself can be performed in a part of the Schatzkammer where there is a wonderful new storage area with a big work table. In this area we are able to maintain exactly the same conditions of temperature and relative air humidity as in the exhibition room.

That said, our general conservation plan for the vestments is as follows: After anchoring the pearls, we anticipate delicately removing the conspicuous old restoration stitches sewn with excessively thick threads. No further treatment will be attempted in the needle painting areas. The loose gold threads should be secured with silk threads selected to match the missing colors, using the smallest number of stitches necessary to keep the gold threads firmly in position. Decisions on how to go about making these repairs will probably vary from one area to the next, especially where there are no traces of the original design or pattern.

My colleague Helmut Trnek is making a study of the iconography and art-historical significance of the vestments. In his view, the goldwork carries a transcendental meaning, following the tradition rooted in early Byzantine art in which gold reflects a sacred meaning symbolizing the Beyond. He is concerned that our conservation work might alter the mystical effects of the gold. Yet, in considering this potential problem, we should not forget that the paraments today no longer display their original effects in any case. In proceeding with our work, the challenge is to find the right balance between an efficacious conservation treatment and respect for the original mystical aspects of these vestments.

Biography

Rotraud Bauer joined the Kunsthistorisches Museum in Vienna in 1969 where she began her specialization in textiles after studying art history and archaeology in Graz, Vienna, and Florence. Since 1975 she has organized and prepared catalogues for several tapestry exhibitions. In 1984, she and several of her colleagues began the project of restoring the coronation vestments of the Holy Roman Empire, which were completed in time to celebrate the reopening of the newly renovated Schatzkammer in 1987.

Three Embroidered Pilaster Panels from the Church of San Pietro at Broni

Francesco Pertegato

The textiles that are the subject of this paper were treated during the period from 1984 to 1985 at the request of the Soprintendenza per i Beni Artistici e Storici of Lombardy.[1] Certainly they do not present the technical difficulties involved in the treatment of the hood of a cope embroidered from a design attributed to Sandro Botticelli[2]; nor can they command the extraordinary historic and artistic interest generated by the embroidery regarded as part of the coronation robes of Corrado II, crowned King of Italy in 1026[3]; nor can they claim the naive beauty of the sixteenth-century orphrey[4]—all of which were recently conserved at our Centro Restauro Manufatti Tessili in Milan. Nevertheless, the complex structure of the pilaster panels from Broni (Pavia)[5] demanded an integrated approach to the problems of conserving the numerous different constituent materials, some of them in worse condition than others. This is the issue I wish to discuss here.

The three panels form part of a set of fourteen hangings that are still used once each year during the solemn festival of San Contardo, patron of the locality. The set came originally from another church. It was acquired by the church of San Pietro on the antique market sometime before 1814[6] and was subsequently adapted, with small modifications, to the different dimensions of its new abode. The decorative design and the technique of the embroidery indicate that the set was made in northern Italy between 1740 and 1750.

Description of the Objects

The three satin-weave silk panels incorporate embroidered motifs (Pl. 15). Their measurements are as follows:

> Panel 1: 459 centimeters x 72.5 centimeters
> Panel 2: 601 centimeters x 89 centimeters
> Panel 3: 599 centimeters x 89 centimeters
> (The two longer panels had been shortened by folding back approximately 50 cm at the bottom.)

The embroidered decoration consists of a gold frame surrounding an ornamental vine that ascends the panel in a sinusoidal curve. Colored silk tendrils decorated with leaves, flowers, and birds sprout from a gold ribbon adorned with small acanthus leaves. The ribbon and tendrils form an undulating design that encompasses putti holding symbolic motifs. These symbolic groups are as follows:

Panel 1: putto with helmet, putto with pastoral shaft

Panel 2: putto holding a dove, putto playing with a drum, putto holding a robe

Panel 3: putti holding framed emblems of a sunflower, an ostrich, and a sitting hen with her brood of chicks

The fabric used as the base for the panels consists of two lengths of undyed satin-weave silk (50 cm wide), sewn at the center along the selvages; the extra width has been folded back. The lining is plain-weave linen attached to the panel by a running stitch of linen thread that takes up the selvages along the center of the panel, leaving the lining relatively loose. This allowed the two layers to remain fairly stable when the panels were hung, while preventing the development of local tensions that could have caused stretching and distortion between the two pieces of fabric.

Along the upper margin of the lining were the remains of a fine but sturdy hemp cord, attached at regular intervals. This cord originally served to hang the panels; this method has also traditionally been used to hang tapestries. A small piece of parchment (approximately 7 cm x 5 cm) attached to the top at the center shows handwriting in sepia-colored ink, probably noting the precise location of each individual panel. Only two parchment fragments of the set have survived, and of these only the one attached to Panel 1 has an inscription that is at least partially legible: "...terminando in Sancta Sanctorum dalla parte dell'Epistola."

Embroidery Techniques

The gold ribbon and the border were embroidered with strips of parallel laid and couched gold threads, secured diagonally with yellow silk. The profile of the inner side of the frame and the acanthus leaves were also worked in laid and couched gold thread. Here the threads were set further apart, thus allowing the underlying satin, painted in monochromatic tones, to be visible. The overall effect was that of a combination of shades of bright and dull gold with overtones of chiaroscuro.

Tendrils, leaves, flowers, and birds were embroidered in loosely worked long-and-short stitch and satin stitch using variously colored silk threads. The extremely naturalistic features of the putti were produced principally by painting on satin-weave silk, again using prominent chiaroscuro effects; the hair was worked in split stitch while the drapery was worked in long-and-short stitch, here and there incorporating gold thread.

The symbolic motifs were the most elaborately worked elements of the design. In addition to the techniques already discussed, the motifs also incorporated a fine silver cord constructed of silver strips wound around a linen core, part of which was exposed so that it could be painted to produce additional chiaroscuro effects. These effects were particularly noticeable in the dove, the drum, and the rope. Silver strips, placed at regular intervals, embellished the bases of some of the coats of arms.

Assembly of the Panels

An analysis of the assembly of these panels revealed that they were produced in a professional workshop organized by division of labor. Some of the work may also have been farmed out to workers based at home.

Ribbons, borders, and chiaroscuro gold elements were embroidered directly onto the satin panels, but the putti, with their symbolic motifs, flowers, leaves, and birds, were embroidered separately, worked in colored silk threads onto a satin-weave silk base that seems to have consisted of several remnants. These embroideries were sewn to the panels, first with long basting stitches in variously colored silk threads (Pl. 16), then with long-and-short stitches around the edges, using a silk thread not

necessarily color-coordinated with the embroidery. A certain monotony of colors apparent in one of the panels may possibly be a result of the different skill levels of those working at home, away from the control of the master embroiderer. The putti were also executed separately: painted on satin, embroidered, then attached to the panels with a vegetable-based glue and finished around the edges with a fine satin stitch.

Such a method of production must have been the standard practice for objects of this scale, intended to be seen from a distance. The aesthetic quality varied considerably from panel to panel. It is likely that the various decorative elements were standard items but that their final arrangement was carried out according to the client's wishes. The number and types of elements to be incorporated probably depended on the price the purchaser wished to pay. Some symbolic groups were presumably more expensive than others, not only because of their more complex embroidery but also because of the greater amount of gold thread used. These costly and elaborate works were probably intended to be hung on the pilaster nearest to the main altar, or perhaps on those of the triumphal arch, since they would have been the ones most in evidence. When all of the embroidered and painted pieces were actually assembled, the design must have been interpreted in a fairly flexible manner so that, for example, a horizontal join in the length of the underlying silk satin could be concealed by an arrangement of embroidered flowers and leaves.

State of Conservation

In order to give a more precise idea as to the conservation problems presented by these pilaster covers, it may be useful to analyze separately the component parts: the basic satin panels, the gold embroidery, the colored silk embroidery, and the painted satin elements.

Basic Satin Panels

The technical feature of the satin weave—that is, the spacing of its binding points—means that it does not stand up well to general wear and tear. The two most important factors contributing to the wear and tear of the panels were tension and abrasion. The latter problem was aggravated first by photochemical degradation and second by the mechanical stress exerted by the sheer weight of the panels and the local tensions set up by the embroidered sections. The embroidery had produced wrinkling within the circular motifs and tension around their edges, causing the panel to split at many points. The distribution of the damage also demonstrated the importance of the central seam and of the gold border in maintaining the panels substantially intact. Where the splits were most extensive, however, the wrinkling at the borders and the abrasion caused those areas of fabric to disintegrate, leaving a number of medium-sized holes (Fig. 1).

There was also some deliberate mechanical damage: that is, holes made to allow for lamps or other projections fixed permanently to the pilasters. Similarly, altering the length of two of the panels to adapt them to their new location caused weakening along the fold line.

Figure 1. Damage to upper areas of panel, detail before conservation.

Figure 2. Detached and broken gold threads, before conservation.

Gold Embroidery

The general loss of resistance in the satin, together with the tensions created by the holes and splits, caused the satin panels to tear even further into the areas worked with gold. These factors also contributed to the loss of silk threads originally used to couch down the gold threads, and, as a result, many gold threads were becoming detached and broken (Fig. 2); in some places they were reduced to a tangled muddle. This situation was aggravated further by the intrinsically stress-producing effect of gold leaf wound around a central core. The extreme flexibility of the satin, the rigidity of the gold embroidery, and the different thicknesses combined to cause particularly disastrous damage at the corners of the frame (Fig.1).

Colored Silk Embroidery

Two factors had contributed to widespread abrasion in the silk embroidery. First, very long stitches had been used, evidently to speed up the work. Second, the silk thread was loosely twisted; this construction allowed for larger areas of fabric to be covered with fewer stitches, again saving time, while rendering these sections more brilliant and glossy. In some parts, so much of the original embroidery had been lost that large sections of the underlying satin were left exposed. This satin—the fabric onto which the embroidery had been worked—proved to be much more brittle than the satin used for the basic panels.

Painted Satin Elements

The harmful effects of light had caused many splits in the sections of painted satin, which were now in danger of falling away from the ground fabric as the adhesion of the glue broke down (Pl. 17). Disintegration of warps had left large areas of weft threads exposed.

Conservation Treatment

Once the linings had been removed, the objects fully documented, and the routine test procedures carried out, it became obvious that the complex structure of the panels, together with the greatly differing problems they presented, necessitated using a combination of conservation approaches: supporting the basic panels, repositioning and securing the gold threads, providing a remedy for the damaged silk embroidery, and consolidating the painted satin parts.

Support of the Basic Panels

It was clear that the use of stitching techniques would not provide a satisfactory support for the panels. This conclusion was reached partly in consideration of the weight of the panels and the fact of their being in a generally weakened condition, which

would have focused the strain of the weight mainly on the stitched sections. Large areas of closely worked couching would also have had a negative impact on the intrinsic brilliance of the satin weave. Finally, we considered the fact that these panels are not museum objects. If they were to be hung high up, once a year, without the care of a specialist, they needed to be resistant. It was therefore decided, with the approval of Soprintendenza per i Beni Artistici e Storici, to provide a total support by adhesion in order to guarantee an even distribution of the tensions produced by the object's weight. Tests had shown that starch or CMC-based adhesive pastes were unsatisfactory because when a panel was rolled around a cylinder (the only possible manner of storing the panels in the sacristy of San Pietro), the glue did not hold the areas corresponding to the edges of the embroidered sections. A film of polyvinyl acetate, softened at around 70 °C, was therefore chosen: This film can be removed easily by simply moistening it, and, when applied with a heat-sealing process, the adhesive does not penetrate the fabric. The support material was polyester multifilament bolting cloth, dyed to the appropriate shade. Apart from being light and extremely flexible, this material also has the advantage of possessing extraordinary mechanical resistance (thirty times that of silk) and longevity. Such characteristics were considered of greater importance than the homogeneity of conservation materials with the corresponding components of the original object. If the chosen method of support does, in fact, work, the future condition of the panels depends entirely on the longevity of the support fabric. Lengthy and expensive interventions can be rapidly compromised by choosing materials with little resistance to the effects of time and mechanical stress. The adhesion was subsequently reinforced by a seam of back stitches running all around the contours of the colored silk embroidery. This reinforcement technique was used to ensure that the uneven tensions between the embroidery and the ground fabric would not cause the panel and the support to separate. With this same end in mind, all of the damaged areas of satin silk were couched down. Where very noticeable tears—particularly along the upper and lower edges— exposed the underlying adhesive film, the film was removed using a spatula iron and a sheet of tissue paper. A local support of appropriately dyed plain-weave silk was then sewn underneath the damaged areas by couching so as to reduce the visual impact of the holes (Fig. 3).

Figure 3, below. As in Fig. 1, following conservation.

Figure 4, right. Gold threads repositioned and secured to the ground fabric, after conservation.

Repositioning and Anchoring the Gold Threads

After the gold threads had been placed in position, they were anchored using the original stitching technique (Fig. 4). For the silver cord, the couching technique used in textile conservation was preferred.

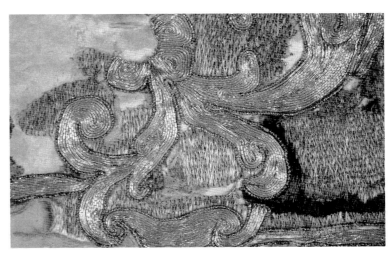

Consolidating the Damaged Silk Embroidery

The long stitches and the virtually untwisted thread used for the silk embroidery were factors contributing to the damage to these threads under the stress of wear and tear. In many areas the underlying satin was also worn, increasing the risk that many of the leaves and flowers would drop off altogether. The technique used to consolidate these areas was couching, adapted in the following manner: Usually, couching stitches form sets of parallel lines aligned with either the warp or the weft. In this case, however, the only points of relative strength lay in the embroidery itself; to take advantage of this strength, the couching was stitched perpendicular to the lines of the embroidery, changing alignment according to the direction of the embroidery thread. Where this technique was applied over the silver strip, the underlying textile fragments were first consolidated with CMC-based glue; then the silver and the embroidery were secured by couching stitches.

Consolidating the Painted Satin Parts

The detached fragments and the bare weft threads on the panels were fixed in position using CMC adhesive paste. This process helped the putti to regain much of their visual integrity (Pl. 18). CMC paste has a very limited power of adhesion, however, a fact that would have compromised the panels the first time they were hung. Conservation of the first panel was therefore completed by covering the painted areas with silk crepeline dyed to the appropriate shade. The edges of the crepeline were consolidated with an adhesive to prevent fraying. This procedure, which is used by many conservation workshops, has a number of disadvantages when applied to large objects. First, silk crepeline does not have great resistance to stress, nor does it have great longevity. Second, its transparency, which rightly makes it so universally praised, is greatly reduced when the embroidery is in high relief with respect to the ground fabric, as in this case, and when raking lights cannot be avoided. Third, the use of the crepeline only in the embroidered areas and not over the entire panel inevitably increases the likelihood that it will become detached around the edges. After consideration of these difficulties, it was decided to use a different material for the second and third panels: a nylon net, also dyed to an appropriate shade. This net offers the advantages of greater transparency combined with better mechanical resistance. Moreover, its weave structure prevents fraying, which means that the stitching remains stable—lending the fabric greater holding power—and that it does not need to be consolidated around the edges.

Reassembly

The linings and the panels were cleaned by immersion in an organic solvent, to avoid shrinking, and subsequently couched down as necessary. A strip of Velcro was stitched directly below the original cord used for hanging, and the linings were then reattached to the panels.

Documentation

Following established practice as required by the Soprintendenza, black-and-white photographs were taken at all stages of the work, drawings were made of the panels' structure, and notes were taken of the inscription and any other historically relevant features.

Notes

1. The Ministero per i Beni Culturali e Ambientali would like to acknowledge the directors of the restoration project, Dr. Mariolina Olivari and Dr. Pietro Marani.

2. See M. Natale, "Sandro Botticelli (cartone di)," (Milan1982):154–155, ill. in b/w:339; A. Mottola Molfino, "Cappuccio di piviale su disegno di Sandro Botticelli," (Milan 1984):341 (plus errata corrige), ill. in b/w:401; and relevant bibliographies.

3. The fragment, now in the Civiche Raccolte d'Arte Applicata of Milan (inv. 2229T), forms part of the group of textiles known as the Dalmatics of Saint Ambrose. See A. De Capitani d'Arzago, *Antichi tessuti della Basilica Ambrosiana*, (Milan 1941); H. Granger Taylor, "The Two Dalmatics of Saint Ambrose?", (Lyons 1983):127–163.

4. The embroidery, which probably formed part of a chasuble, belongs to the Museo Civico of Bolzano (inv. 21832).

5. These panels are discussed by A. Tomasi in "Broni, Storia, arte, fede," published in *Ticinum* (Pavia 1940):3. Ten of the fourteen panels were restored in 1958 by the firm of Viesi at Cles (Trento) under the supervision of the Soprintendenza alle Gallerie of Milan. (I would like to thank Mons. Beccaria, arciprete of Broni, who kindly communicated this information.)

6. The parish archive still preserves the document relating to the purchase of these panels by the arciprete Maggi. They were purchased in Milan from the antique dealer Casortelli (or Casertelli), who declared that they came from the church of San Paolo Converso in Milan. (This information was obtained from catalogue entry no. 03/00020970 of the Ministero dei Beni Culturali, produced by A. Guarnaschelli in 1974 and deposited in the archive of the Soprintendenza i Beni Artistici e Storici of Milan.) This provenance is—chronologically speaking, at least—possible insofar as in 1806 the order of the Angeliche, to whom the church was annexed, was suppressed; see A. Morandotti, *San Paolo Converso in Milano* (Milan n.d.) 10. In 1844 the church was already being used for storage purposes (see C. Vallardi, in *Itineraire d' Italie* [Milan n.d.]).

References

De Capitani d'Arzago, A.

1941 *Antichi tessuti della Basilica Ambrosiana*. Milan.

Granger Taylor, H.

1983 The Two Dalmatics of Saint Ambrose? *Bulletin de Liaison du CIETA. Nos. 57–58.* Lyons.

Morandotti, A.

n.d. San Paolo Converso in Milano. Milan.

Mottola Molfino, A.

1984 Cappuccio di piviale su disegno di Sandro Botticelli. *Museo Poldi Pezzoli. Arazzi, tappeti, tessuti copti, pizzi, ricami, ventagli.* Catalogue entry no. 145. Milan.

Natale, M.

1982 Sandro Botticelli (cartone di), Incoronazione della Vergine (cappucio di piviale). *Museo Poldi Pezzoli, Dipinti.* Catalogue entry no. 90. Milan.

Tomasi, A.

1940 Broni, Storia, arte, fede. *Ticinum.* Pavia.

Vallardi, C.

n.d. *Itineraire d'Italie.* Milan.

Biography

Francesco Pertegato is the founder of the Centro Restauro Manufatti Tessili in Milan, a private textile restoration workshop established in 1980. He began his work in textile conservation at the Museo Poldi Pezzoli after training at the Victoria and Albert Museum. He is the author of a general introduction to textile conservation that appeared in the *CISST Bulletin* and other essays and case histories on the subject.

Restoration of a Seventeenth-Century Chasuble at the Musée Historique des Tissus in Lyons

Marie Schoefer and Eric Houpeaux

Figure 1. Reconstruction of the costume from the chasuble.

Figure 2. Diagram of general design of chasuble.

The subject of this paper is a chasuble consisting of two separate pieces, preserved at the Musée Historique des Tissus in Lyons (inv. 890XV 8 = Ra 30, 25113, 25113/2). The chasuble was constructed from parts of a costume: a doublet and breeches (Fig. 1). The embroidery is executed with metallic thread on red satin in a pattern of arabesques and fleurons on foiled frames (Pl. 19). The general design is organized in horizontal layered bands. The back shows the remains of stitches in the shape of a cross, added after the chasuble was acquired by the museum. The back and the front of the chasuble consist of various fragments sewn together (Fig. 2); these fragments have been identified by comparing them to patterns published by Norah Waugh, as seen in the accompanying diagrams (Figs. 3,4; Waugh 1964:24). Various details warrant special identification:

A and A': the two front parts of the doublet
B: The back of the doublet

Three yokes show vertical lines or slashes underlined with gold thread. Using the diagram in Figure 1 as a guide, we can identify the front parts of the chasuble (A and A') with the front of the doublet and B with the back of the doublet, which shows five slashes. The A' piece displays a gold underline in the turning of the seam of the median line that corresponds either to the edge of the yoke or to another slash. This would lead to the hypothesis that the piece was originally larger and that it was

Front	
A & A': Front of doublet	
B: Back of doublet	
C & C': Undetermined	
D & D': Front skirt	
E & E': Side skirt	
" Traces of red twist	

Back	
F" completes F	
G" completes G	
F-F" & F' Breeches' front yoke	
G-G" & G': Breeches' back yoke	
"""" Satin B selvage	
＼ Positioning of F"& G"pieces of breeches	
--- Projected shape of completed pieces	

Figure 3, above. Doublet 1620-1653 and breeches 1630-1640 from The Cut of Men's Clothes 1600–1900, *by Norah Waugh (1964:24).*

Figure 4, center and far right. Doublet and breeches ca. 1630 from The Cut of Men's Clothes 1600–1900 *(Waugh 1964:23).*

recut when the chasuble was pieced together (not very likely considering the concern for saving material in piecing together the chasuble). Both C and C' pieces are undetermined. They have underlined closed slashes. If the seams that join them to B were part of the original construction, these pieces would then have to be considered to be the doublet. They could also have been the sleeves, since no other piece can be assigned to this part of the garment. There is, however, no physical evidence to support this idea. The D and D' pieces would be the doublet's front tab, as identified by analogy to other samples. The E and E' pieces would be the lateral tabs. The upper portions of these pieces show stitches of red thread aligned in a way that suggests the presence of eyelets, probably designed for lacing the breeches and doublet together. One of the eyelets bears a residue of saffron flax or hemp that could be one of the laces for the breeches. Remnants of red taffeta also found around the eyelet could be regarded as the lining.

— Metal thread, silver
— Metal thread, golden

Figure 5. Transfer of an embroidery motif.

On the Back of the Chasuble

The six main pieces present a structural analogy:

1. A seam of red thread joins satin and backing together with two complementary yokes; the embroidery covers the seam with its regular design.
2. By transferring the drawings of the embroidery of the F" and G" pieces to a transparency (Fig. 5) and comparing them with the other pieces, we find that the embroidery shows the same characteristics as those of the F piece, which it thus completes as positioned in the diagram; the same applies to G" in relation to G.
3. Being reconstituted in this way, the four pieces are comparable to the four pieces of a pair of breeches.
4. Two long cuts on pieces F–F" and F' could correspond to the darts of the hips. These two pieces would therefore be the two fronts.
5. G–G" and G' would be the back of the breeches.
6. The two upper pieces that make up the back of the breeches are cut from two different satins. The satin B used for the waistline seems of inferior quality. Possibly the creators of this garment felt that the parts hidden beneath the lappets could be made out of a cheaper fabric.

As can be seen from photographs of the reverse side, some pieces have a backing, while others do not (see Pl. 20). The lappets and breeches, which are worn loose,

are backed to hold their shapes. The doublet, which fits the body tightly, does not need a backing. Some pieces do not show any embroidery in the turning of the seam. In keeping with the pattern of the motif, the embroidery ends before reaching the cut edge of the satin. In the E' and G' sections, several fragments of satin are sewn together to form a single piece. The seam joins the satin together, but the backing and the embroidery cover this seam so that it does not stand out. This technique was probably developed to save precious and costly fabric. These two observations help to demonstrate how the embroidery was executed on pieces already cut. It should be noted that in the manner characteristic of the assembly of the garment, these seams are couched and sewn with a pink thread and are left open in many places.

Methods of Working

The embroidery is executed either on a single layer of red satin (two kinds of satin coexist) or on red satin mounted on beige linen canvas, in which case the embroidery is attached through both layers.

The characteristics of satin A are as follows:

- 8-end satin
- 209 silk warp strands/centimeter
- 36 silk weft strands/centimeter (double strands)

The characteristics of satin B (yokes for the breeches) are as follows:

- Garnet-red 8-end satin
- Approximately 144 silk warp threads/centimeters (8 binder threads/0.5 cm)
- 34 silk weft threads/centimenters (double strands)

A selvage is found in the turning of the central seam of the F' and G' pieces and is composed of the following:

- 5 selvage cord warp threads
- 8 green warp threads
- 8 white warp threads
- 8 green warp threads
- 8 white warp threads

The selvage is woven as an 8-end satin. Further technical analysis is impossible because of the position of the sample.

The characteristics of the linen backing are as follows:

Beige linen canvas

- 14–15 flax or hemp warp threads/centimeter (single Z-formation thread)
- 14–15 flax or hemp weft threads/centimeter (single Z-formation thread)

Metallic Embroidery Threads

The metallic threads used in the embroidery are composed of the following:

- Golden Twist: two-ply gold filament in Z-formation, twisted around in S-formation on an S-formation core of yellow silk
- Silver Twist: two-ply silver filament in Z-formation, twisted around in S-formation on an S-formation core of white silk

The metallic filaments were analyzed under X-ray fluorescence spectrometry in the laboratory of the Musée d'Art et d'Histoire in Geneva (Figs. 6,7). On the graph the golden foils give off definite peaks of brass (dominant), of silver, and of gold, which implies the presence of a golden brass/silver alloy foil on one side. In addition to the presence of silver, the silver filament reveals the iron peak. It is not certain

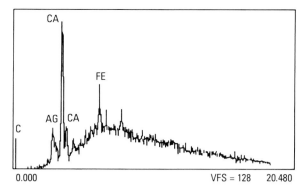

Figure 6. Analysis of metal thread no. 25113, silver.

Qualitative Element Identification				
Peak Listing				
	Energy	Area	El. & Line	
1	0.223	181	C	KA
2	2.967	162	AG	LA
3	3.695	885	CA	KA
4	4.028	154	CA	KB
5	6.419	230	FE	KA

Laboratoire MAH, Geneva

Figure 7. Analysis of metal thread no. 25113, golden.

Qualitative Element Identification				
Peak Listing				
	Energy	Area	El. & Line	
1	0.219	68	C	KA
2	0.050	490	CU	KA

Laboratoire MAH, Geneva

whether this is caused by dirt on the thread (left unwashed for the analysis), as indicated by the presence of a high concentration of calcium, itself a component of dust, or by a component of the alloy, which would be unusual. These metallic threads are attached by simple couching. The term "Chinese-type embroidery," as defined by Th. de Dillmont in *L'Encyclopédie des Ouvrages des Dames* (n.d.), does not seem an appropriate description of this technique because it involves a decorative element in the placement of the couching stitches. In many of the Chinese-type embroideries, the thread used to secure the metallic threads is of a color contrasting with the metallic threads.

History of the Chasuble

The history of the chasuble since its acquisition can be traced through its inventory numbers. On the right side, the lower left portion of the front bears a label marked "25113/2 Hood? Italy 16th century" and a label marked "I 3624." On the right side of the lower left portion of the back, a label reads "Ra 30/25113," and on the reverse side, on the lower left, a glued-on label reads "1 B."

Concerning the back, the Ra 30/25113 label agrees with the inventory of textiles and religious vestments conducted by F. Guicherd, which includes reference to the chasuble under number Ra 30. The number 25113 is the museum entry number, under which we find another call number 890.XV.8.

The museum's entry register gives the following description of the object: "Hood and back of chasuble. Red satin embroidered with gold. Venice 16th century." From the inventory sheet, we learn that the chasuble (this term is never used on the sheet) was acquired in 1890 through an exchange made with the Musée d'Archeologique in Lyons, which had itself acquired the garment in 1859. The inventory sheet also states that the chasuble bore the Orfray cross number 903.XV.7, which depicts Christ on the cross, embroidered with wool on canvas. The embroidery is roughly executed. We learn from its inventory sheet that this cross entered the Musée Historique des Tissus in Lyons in 1903 after having been acquired from Hochon. In other words, the cross was acquired after the chasuble. It was attached to the back of

the chasuble for display purposes only; we cannot determine when it was attached and removed.

The identification of the garment pieces with the ones described by Norah Waugh leads us to date the garment from the first half of the seventeenth century (circa 1620–1630). Let us note, among other things, the similarities with the garments of Gustavus II of Sweden (circa 1620), made in Hamburg and preserved at the Stockholm Cabinet des Armes. From references in the works of J. Laver (1950) and L. Godard de Donville (1978) we came to realize that the garment had been completely restructured about every twenty years during the course of the sixteenth and seventeenth centuries. Each time, the yoke was cut in accordance with the style of the period. The final reconstruction reflected the period of Louis XIII.

As to the origin of the chasuble, that remains unknown. Given the international features of the iconography, its origin was certainly European. The style of the embroidery, sometimes called *filigreed* (Cox 1902) came down from the Italian Renaissance. This style can be compared to a type of bookbinding called *ferronnerie*. But the widespread use of this style during the sixteenth century makes it difficult to identify the exact origins of the piece (see Gustavus II's garment embroidered in Hamburg). Probably bequeathed to the Church, the garment was remade into a chasuble shortly after that time (the fabric was hardly worn). The shape of the chasuble would correspond to this period. The square look of the back also suggests this early reconstruction. We can therefore expect to date the early history of this garment/chasuble back to the first half of the seventeenth century.

Previous Restorations

There have not been many earlier restorations. A few seams have been stitched together with a white cotton yarn. It does not appear that any attempt was made to reattach the metallic thread.

State of Conservation

The front and back of the chasuble are separate. The satin has not suffered much. It is still strong and hardly worn except at the folds or in some rare places. The garment is quite dirty, covered with a layer of dust and soot on the epaulets where the satin has actually turned black. Since the embroidery in these areas is also completely detached, it appears that the epaulets had been folded back on the wrong side during a prior exhibition. Purple-black spots stain some of the yokes; the larger stain is found on the lower portion of the F' piece. The random scattering of stains all over the chasuble leads one to believe that they date from the time the garment was made. One seam and one slash have recently been fixed with white thread. Some seams are gaping, but the others are more or less in good condition. Both darts, as well as the median seam of the back, were completely resewn with pink thread when the cross was affixed. These stitches are quite noticeable and aesthetically displeasing. The stitches attaching the metallic threads are generally worn to the extent that one-third of them must be restitched. Some metallic threads are missing, particularly from the center part of the front. The silver metallic thread has oxidized and is therefore missing in many places.

The pointed end of one of the epaulets and one foil from the front of the chasuble are also missing. Two notches (neatly executed, as if cut with a razor blade) are found on the waistline yoke of F'. On the reverse side of the front, at the corners, there are remnants of glue with bits of cartoon.

Steps Taken

We removed all remaining threads from prior restorations (pink stitches executed to attach the cross, seams sewn with white thread). All gaping seams were resewn with red silk thread in running stitches.

Reattaching the Metallic Thread

The metallic threads were resewn into proper position with silk thread (dyed to match the metal) in couching technique. Where possible, the new stitches were sewn through the original holes. This operation was performed on a table with openings that allowed the restorers to work the material from both sides. A lamp placed beneath the fabric illuminated the holes, making them easy to spot and easy to pass the needle through. Traces of the original drawing, as well as the impression left in the fabric by the metallic threads throughout the years, also assisted us in putting the loose threads back into place as accurately as possible.

Washing

The chasuble did not undergo any particular preparation before washing. First the colors were tested for fastness. Then, each piece, front and back, was simply placed on a sheet of Melinex (transparent polyester) to facilitate its handling.

The first bath contained 0.05 milliliters of the neutral detergent Tinovetine (Ciba-Geigy) per liter of demineralized water. The wash solution dissolved the specks of glue on the reverse side of the front as well as the glue adhering the label to the back. Soon the extremely dirty chasuble exhausted the detergent. It no longer produced suds, and patches of grime rose to the surface. The second bath contained a lower concentration of detergent. The first rinsing in demineralized water was followed by two rinsings in soft water and a final rinsing in demineralized water.

Drying

The chasuble was laid out to dry on soft Isorel covered with protective plastic. The pieces were pinned down, starting from the center. The pins were placed along the seams of the various yokes after they had been gently stretched so as to flatten each piece. The seams closing the slashes were also pinned down to prevent them from opening up as a result of fabric shrinkage. Since the left foil of the front is only fragmentary and needs to be completed by an accessory piece, the turning of the seam was unfolded. The same was done for the right (pointed) portion of the back.

Assessing the Washing

The washing removed a great deal of grime from the fabric. The black stains on the back and front, however, did not dissolve. The golden metallic threads have regained much of their brilliance. As for the silvery threads, while they have lost their grime, they have not regained their shine because of their state of oxidation. The front is clean, whereas the back still has some dirt marks, particularly in the epaulet area. During the drying process the turning of the seams did not flatten properly (right side up), requiring an adjustment on the reverse side. To do this, the folded parts were steamed, then realigned in the right direction. They were kept in place by a plate of glass humidified with steam and held flat by a small weight until they were dry (about two hours). The median seam of the back was taken apart and its edges flattened out in the manner described above, revealing traces of glue that had not dissolved during the washing. Various other attempts at dissolving them did not succeed. A strip of beige linen was cut and used to join the two pieces of the back, which were sewn edge to edge onto the linen strip with restoration stitches. Because the edges were not perfectly straight, a few slits revealed the beige linen on the right side. To hide them, pieces of red satin were inserted between the linen and the chasuble. Since the dart of the F' piece was open, the piece that was used to reinforce the median seam was also used to reinforce the dart by the same technique.

Further Treatment

To substitute for the missing parts, we tried using satin dyed to a suitable red. The first experiments proved unsatisfactory. Being brand new, the satin had a shine that clashed with that of the chasuble. We then tried a lighter, less shiny satin. To give it shape, the satin was mounted on red cotton fabric secured with running stitches. Pieces were cut and prepared to replace the missing foil on the front and the pointed part of the back. They were inserted underneath the edge to be completed and attached with restoration stitches. The edge was turned in so as to follow the contour of the garment. Since the front is not symmetrical, it proved impossible to apply the right foil to the left one; to do so would have thrown the whole piece out of balance. The turnings were notched and flattened out with steam and glass plates.

The red backing for the additional satin clashed with the original beige backing. It was not possible to back the satin with beige because the light color would have shown through the transparency of the satin. After sewing these pieces together, we decided to tone down their brightness even further by superimposing red crepeline sewn at the edge of the original with blind hem stitches and with running stitches along the line of the piece. Cotton fabric dyed to a matching red served as lining. Each piece was lined separately. Both back and front were positioned to be joined. Each flap of the back was sewn onto the upper line of the front with a running stitch. The lining that had been left open on the shoulder to allow for these maneuvers was now sewn down. An opening for observation was made on the wrong side of the front.

A mannequin was constructed to the appropriate size to support and display the chasuble. The mannequin was dressed with an unsized molleton (thick, soft flannel); its visible parts (neck, sides) were covered with the same fabric used in the glass display case (Pl. 21).

Conservation

This piece was restored for the occasion of the remodeling of the rooms on the second floor of the Musée Historique des Tissus in Lyons. The display includes a diagram explaining the transformation of the garment into a chasuble. The piece is exhibited in a glass showcase, under low-intensity lighting, in rooms where both temperature and hygrometry are monitored.

References

Cox, Raymond

1902 *L'art de décorer les tissus*. Lyons: A. Rey.

de Dillmont, Th.

n.d. *L'Encyclopédie des Ouvrages des Dames*. Alsace.

Godard de Donville, Louise

1978 *Signification de la mode sous Louis XIII*. Aix-en-Provence: Edi sud.

Laver, James

1950 *Le Costumes des Tudor à Louis XIII*. Paris: Hougons de France.

Waugh, Norah

1964 *The Cut of Men's Clothes 1600–1900*. London: Farber.

Biographies

Marie Schoefer has been responsible for the restoration workshop at the Musée Historique des Tissus in Lyons since 1984. In 1986 she joined the Institut Français de Restauration des Oeuvres d'Art in Paris as head of the Textile department. She received her main training in textile conservation at the Abegg Foundation. Hampton Court Palace, the Bayerisches Nationalmuseum, and institutions in the United States were volunteer experiences.

Eric Houpeaux is a student at the Institut Français de Restauration des Oeuvres d'Art.

The Restoration of a Twelfth-Century Liturgical Sandal at the Musée Historique des Tissus in Lyons

Marie Schoefer and Denise Lestoquoit

Figure 1, top. Sketch of fragment Rb 98/25078 with general measurements. Sandal fragment consisting of a piece of three-lat samite (I) and a piece embroidered with gold spirals and foliated scrolls surrounding a human form (II).

Figure 2, above. Sketch of fragment Rb 99/25079 with general measurements. Fragment consists of a samite embroidered in gold (III) and a braid of gold thread fabric (IV). Foliated scrolls and leaf patterns surround two griffons facing each other. Only one remaining thread holds these two pieces together.

Figure 3, above. Sketch published by de Farcy (1890), location not cited.

Three fragments of a liturgical sandal have been preserved at the Musée Historique des Tissus in Lyons (inv. 25078 and 25079; Pl. 22). They were acquired in 1889 from Fulgence, a Parisian antique dealer. The first fragment (fragment I, inv. 25078; Fig. 1) consists of a three-"lat" samite in red, yellow, and green. This fabric belongs to the family of twelfth-century Spanish silks or to that of Byzantine silks of the same period.

The other two pieces of fabric (fragments II and III, inv. 25079; Figs. 1,2) are plain samites, each embroidered with a different design. The embroidery is done with gold thread in *couché rentré* technique, highlighted in places by a split-stitch embroidery in red silk. Each piece has a plain samite background, each of a different color. A human form surrounded by foliated scrolls decorates one of the pieces, while the other shows two griffons head to head, surrounded by foliated scrolls. Attached to this latter piece is the remains of a braid (fragment IV) featuring a design of small diamond shapes, woven in the technique of a tablet loom, with gold and red silk thread. Figures 3 and 4 illustrate the outlines and dimensions of the fragments.

Louis de Farcy's book, *La Broderie du XIe siècle jusqu'à nos jours*,[1] has an example showing a very similar design (Fig. 3). The griffon on de Farcy's fragment is exactly the same as the one on the Lyons fragment. Unfortunately, de Farcy does not indicate the location of his example, making it impossible to study it firsthand. A twelfth-century episcopal sandal at the Musée Cluny in Paris (inv. CL 12113) also depicts a griffon. After studying the Cluny shoe, we became convinced that it was the mate to our sandal. We discovered its existence only after the restoration and reconstruction of the Lyons shoe. Other examples of episcopal shoes also served as references for our work (Figs. 4–6).[2]

A technical analysis of the two embroidered pieces by Felix Guicherd, the first analyst of weaving techniques at the Musée Historique des Tissus, revealed the following differences between the two pieces:

- No. 25078: warp thread count, about 28 main threads per centimeter; weft thread count, 45 passes per centimeter
- No. 25079: warp thread count, 32–36 threads per centimeter; weft thread count, 60 passes per centimeter

Figure 4, right. Drawing of Saint Edme's sandal, circa 1240.

Figure 5, below. Drawing of Saint Peter of Luxemburg's sandal.

Figure 6, far right. Drawing of Saint Aldegonde's sandal, from an ancient drawing showing the decorated sole of a shoe, circa 1240.

The two pieces are nonetheless embroidered with the same couching stitch, outlined (on one piece only) with a stem stitch or a split stitch in red thread (just as on the shoe preserved at Cluny). The gold threads used for both the embroidery and the braid are made of gold strips twisted in S-formation around a silk core. The threads have been analyzed by Anne Rinuy, chemist at Musée d'Art et d'Histoire, Geneva. Her analysis revealed fine gold worked in the following method: One leaf of beaten gold was cut into strips of about 200 μ (0.2 mm). The thickness of the strips varied between 11 μ and 17 μ.[3] Each strip was then wrapped in a spiral around a silk core.

The sole has also been analyzed by Mr. Guicherd. The fabric is a three-lat samite. The warp is in a ratio of two main threads to one binder thread and contains single silk thread fibers in a light Havana color in Z-formation. The thread count is 30–32 main threads per centimeter. The weft has a ratio of three silk wefts in red, yellow, and green; the thread count is 33–39 passes per centimeter. This part of the sole is still in fairly good condition compared to the other parts, but nevertheless remains very fragile.

The reverse side of the embroideries is in very poor condition. The silk has suffered greatly from age and from the condition of conservation. Nevertheless, the gold threads are still bright, though brittle and tarnished by dust and various residues.

After careful study of the fragments—observing their shape, their stitchings, and their folds, as well as other examples mentioned above—we saw two possible courses of action: (1) preservation of the fragments as such, treating each piece as its condition dictated, or (2) reconstruction of the episcopal shoe from the fragments that we were almost certain comprised its main components. Upon careful consideration and with the approval of our curator, Pierre Arizzoli-Clémentel, we chose to proceed with a reconstruction after assuring ourselves that this course would not damage the fragments in any way. As a measure of precaution, we made a plain cotton model of the existing pieces to work with in developing an exact procedure so that we could avoid unnecessary handling of the fragile fragments during assembly. Having made this choice, we stipulated that the reconstruction had to be reversible to allow for changes in the future if necessary.

This decision was based on the belief that these various fragments belong to the same shoe; they therefore all underwent the same treatment for cleaning and mounting on a backing material.

Figure 7. Detail of Fig. 2.

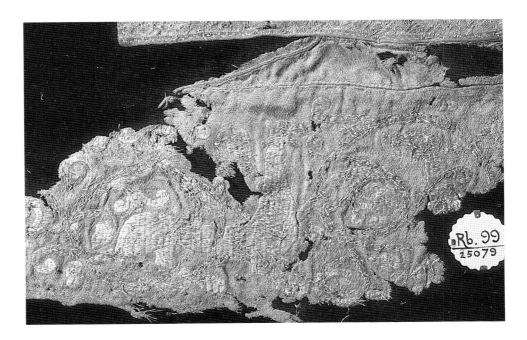

Condition before Treatment

The pieces were dirty and dusty and had become very fragile because their silk material was rotting (Fig. 7). It was difficult to touch the pieces without damaging them in some way.

There were bare spots caused by the aging of the material, corrosion caused by dirt, dust, and pollution, and the effects of being sealed in a tomb. However, the gold threads of the embroidery and the braid seemed to have aged better than the other parts. Despite the dust, they still sparkled. On the lower right section there was a whitish deposit on the silk, probably mildew caused by the dampness of being buried. The sole, of a three-lat samite, was still fairly solid compared to the embroidered part, which was crumbling.

Cleaning

Preparation

The surface dust was removed by blowing air through a pipette. The deteriorated state of the material could not tolerate complete immersion in water. Instead, we adopted the following procedure.

Washing

Each piece was placed on a sheet of Melinex (transparent polyester), which was then positioned on a glass plate. A solution of demineralized water and 5-percent absolute ethanol diluted to 30 percent (added to lessen the water's surface tension and to allow it to penetrate the fibers better) was sprayed onto the piece with an atomizer. The piece was left to soak for about fifteen minutes; then the glass plate was tilted so that the dirty water could run off. The same method was used for rinsing: spraying and tilting the glass plate. When the rinse water from the fabric ran off clean, the rinsing was halted. The piece was left on its support to dry. First, we gently dabbed it with a sheet of cellulose to remove excess moisture. The threads were put back into place insofar as we could determine where they belonged. Finally, we placed a few small glass plates on top of the piece to hold it in place while it dried in the open air.

Condition of the Pieces after Cleaning

After cleaning, the gold had become shinier and the color of the samite had brightened; in general, the threads stood out better.

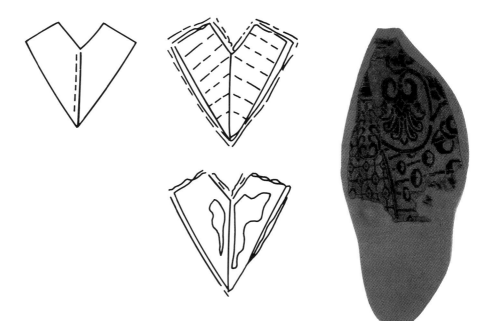

Figure 8, right. The two fabrics making up the slipper stitched together as indicated.

Figure 9, center. Sketch showing dyed crepeline superimposed on the cotton backing and held in place by parallel rows of stitching about 5 cm apart.

Figure 10, below right. The fragments positioned on the prepared backing and covered with another layer of crepeline.

Figure 11, far right. Consolidation of the sole secured to backing.

Assembly and Reconstruction

As mentioned, our bibliographic research and observation of the fragments guided us in making a model of plain cotton before putting together the final slipper model on which the preserved pieces were to be applied. The final model was made using cotton fabric dyed with direct dyes manufactured by Ciba-Geigy.

Procedure for Reconstructing the Piece

Since the backgrounds of the two embroidered pieces were slightly different in color, one of the two backings forming the upper part of the slipper was dyed reddish and the other greenish in color in order to blend with the original fabric.

The two fabrics making up the slipper were stitched together as indicated in Figure 8. Dyed crepeline was superimposed on the cotton backing to approximate the color of the original as closely as possible. The crepeline was held in place by parallel rows of stitching about 5 centimeters apart (Fig. 9). The fragments were then carefully positioned on the prepared backing and covered with another layer of crepeline; parallel rows of stitching "sandwich" the fragments between the two layers of crepeline (Pl. 23, Fig. 10).

The sole was mounted on a backing of cotton and crepeline to give the cotton fabric the appearance of silk. The entire unit was secured to the backing with restoration stitches (Fig. 11).

The later discovery of the Cluny shoe, which matches the one discussed here, shows us with certainty that the three-lat samite in the form of a sole is in fact only the lining of the sole and not the sole itself, which, by analogy to other examples, should be made of cork or leather.[4] We have come across no remnant of the lost sole.

The lower edge of the upper shoe was sewn to the lining of the sole; then the median seam of the heel was sewn closed. The braid was stitched to the top of the shoe after having been consolidated with a piece of lightweight cotton (dyed red) and covered with beige crepeline (Pl. 24). An opening was made on the side of the shoe, following the models of the slipper from the treasury of Brixen and that of Saint Peter of Luxemburg (see Fig. 5).

Display and Preservation

The shoe is displayed on a stand in a glass case, positioned so as to show the top and lower parts. It is loosely stuffed with polyester. Relative air humidity and light are carefully controlled.

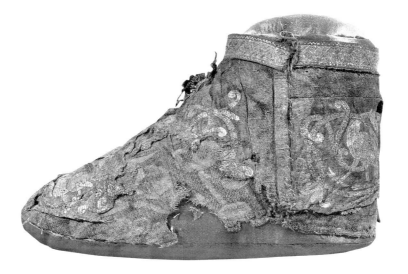

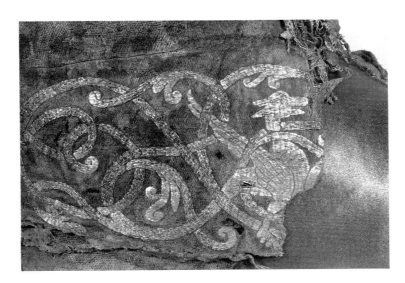

Figure 12, above. Fragment from the Musée des Arts Décoratifs, Paris: 16341/1c. Probably the lining of the shoe from the Musée Historique des Tissus, Lyon.

Figure 13, above right. Episcopal shoe from the Musée Cluny, inv. CL 12113, showing the lining of three-lat samite. Note the side opening bordered with gold, which is missing from the Lyons shoe. The gold embroidery is sewn onto a different ground with different motifs.

Figure 14, right. Inv. CL 12113, Musée Cluny. Detail of a side of the shoe, showing the samite and the gold embroidery. The bird decoration shown here is missing from the Lyons shoe.

Description of the Musée Cluny's Shoe

The chance discovery of the second shoe, forming a pair with ours, allowed us to confirm the suppositions that had guided our assembly of the fragments. I repeat, though, that the second shoe did not provide a model for our work. We discovered it only after completing the reconstruction described above.

The Musée Cluny likewise acquired its shoe from the Paris antique dealer, Fulgence. It was bought in 1890—i.e., one year after the purchase by the Lyons museum—for the sum of 280 F.[5] A note in the unpublished catalogue of Madame Amelie Lefebure states that the shoe had been found in the grave of a Perigueux bishop. This remark is quoted also in connection with the embroidery fragment showing two animals head to head, published in L. de Farcy's book. Some notes by Mr. Donald King in the Musée Cluny inventory file draw attention to the presence of similar motifs on the shoe lining and on samite fragments, number 16341 and number 16335, which are kept at the Musée des Arts Décoratifs in Paris (Fig. 12). One of these pieces bears the same motif as that found on the lining material of the Cluny and Lyons shoes (Fig. 13). Could it be part of the missing lining from the Lyons shoe? A technical analysis in Paris will be required to confirm this possibility.

The same gold embroidery stitches (drawn-in couched stitches) are found on the Cluny shoe. The embroidery is done over a samite background, but the samite is not the same all over. It is reddish, and some of it is two- or three-color with motifs.

The embroidery support for the Lyons piece is made up of two different, but plain, single-color samites.

The embroidered subjects are varied, but the *rinceaux* are the same. Both show griffons head to head. We find a human form on the Lyons piece that is not, or is no longer, present on the Cluny shoe. The Cluny shoe has two birds not found on the Lyons model (Fig. 14). The assembly seams still extant on the Lyons shoe are symmetrical with those of the Cluny model. The braiding that trims the ankles is the same on both shoes. On the Cluny shoe, the braiding around the vertical opening where the foot fits into the shoe is still present (see Fig. 13); on the Lyons shoe it is missing.

The sole remains the main focus of our attention in this paper. The reconstituted shoe at the Lyons museum shows the sole lining with the right side facing out, when in fact, since it is a lining, it should face in toward the inside of the shoe. This is the important point brought about by the discovery of the Cluny shoe. Without it we could not have understood the function of this fine silk lining. As a result, it was decided to mount the sole lining fragment between two layers of silk crepeline (through which it is visible) to consolidate it. It was then replaced in its original position in the shoe.

Conclusion

Before the discovery of the second shoe, we were mistaken in thinking that we had the sole, when what we had was actually the lining. The beautifully designed sole of the shoe of Saint Aldegonde (see Fig. 6) suggested, by analogy, that our fragment was also originally the sole. Without the example of the Cluny shoe, we would not have become aware of this error, and thus the chance discovery of the mate (outside of published sources) added an important element to our overall knowledge.

The treatment discussed here demonstrates the value of research as well as restoration. Indeed, each restoration can benefit from research that goes beyond simply consulting textile publications, which often lack specific information. It is essential to supplement bibliographic research with studies of existing pieces which, as in our case, might reveal important details that would otherwise go unnoticed. Moreover, the choice of a reversible method of restoration is fully justified by the case put forth here, and we will be able to revise the first reconstruction now that this important element has been added to our understanding of the piece.

Acknowledgments

The authors wish to thank Mrs. Anne Rinuy, assistant curator of the laboratory of the Musée d'Art et d'Histoire, Geneva and Mr. Jean Wüest, curator of the laboratory of the Musée d'Histoire Naturelle, Geneva. They provided the analysis of the gold threads by X-ray fluorescence, electron microscope scanning, and optical microscope photography. Mr. Eric Houpeaux, student in textile conservation at IFROA in Paris, found the mate to our shoe at the Musée Cluny. Mr. P. Arizzoli-Clémentel, curator of the Musée Historique des Tissus and the Musée Lyonnais des Art Décoratifs, assisted us in making the decisions and choices mandated by this conservation treatment.

Notes

1. Louis de Farcy, *La Broderie du XIe siècle jusqu'à nos jours* (1890), Plate 14 with the caption: "Short collar embroidered with intertwining animals, from the collection of Mr. Gay. This gold embroidery was found in the tomb of a bishop of Perigueux who died in the twelfth century."

2. Examples shown in Figs. 3–6 published in de Farcy (note 1), p. 325; Charles de Linas, *Anciens vêtements sacerdotaux et anciens tissus conservés en France* (1860–1863): 2,12,124.

3. Electron microscope photographs were taken by Jean Wüest of the Musée d'Histoire Naturelle, Geneva.

4. We are aware of only one example with a cork sole. It is part of the treasury of the cathedral of Lausanne in Switzerland. See also the sole of St. Aldegonde's shoe (Fig. 6).

4. We are aware of only one example with a cork sole. It is part of the treasury of the cathedral of Lausanne in Switzerland. See also the sole of St. Aldegonde's shoe (Fig. 6).

5. In her unpublished catalogue, A. Lefebure notes the presence of a shoe of a similar type in the treasury of the Sens cathedral. It remains to be studied in precise detail. Also, we have yet to locate the fragment published in de Farcy's book (Fig. 3) depicting the same animals, head to head, as those that appear on our two shoes.

References

de Farcy, Louis

1890 *La Broderies du XIe siécle jusqu'à nos jours*. Angers: Belhomme.

de Linas, Charles

1860/ *Anciens vêtements sacerdotaux et anciens tissus conservés en France*. Paris: Librarie archéologique de
1863 Didron.

Biographies

Marie Schoefer is responsible for the restoration workshop at the Musée Historique des Tissus in Lyons since 1984. In 1986 she joined the Institut Français de Restauration des Oeuvres d'Art in Paris as head of the Textile department. She received her main training in textile conservation at the Abegg Foundation. Hampton Court Palace, the Bayerisches Nationalmuseum, and institutions in the United States were volunteer experiences.

Denise Lestoquoit is a graduate of the Institut Français de Restauration des Oeuvres d'Art.

Second Sight: Further Investigation into the Construction of Ecclesiastical Embroideries and Tapestries

Stephen Cousens

The purpose of any conservation intervention is to establish the level of decay of an object and to return it to its original form as closely as possible so that the object may reflect the original artistic concept. The standard preliminary procedure in carrying out this commission is to compile a condition report. This report identifies the object's materials and construction techniques and establishes the incompleteness of the object and the changes and decay the object has undergone. In order to create a clearer picture of the object, it may be necessary to carry out analytical research in a laboratory. In any event, consultation with the curator is necessary before treatment begins.

During conservation treatment, further information regarding the technical composition of the object may be discovered, and this information is added to the documentation. Photographs and drawings may also be made to back up the written information. Many embroideries and tapestries are mounted or lined as part of their conservation treatment, and, in the process, useful information is sometimes concealed from future researchers. Thus, good documentation is essential to avoid unnecessary handling of the object at a later time and to ensure that interesting information regarding the construction is not missed altogether.

Although it has become more common in recent years for some technical information to be included in published material regarding textiles, this information is usually restricted to mere identification of materials and techniques. In the case of woven tapestry, the warp count is sometimes given. Scientific investigation into the dyestuffs employed in groups of tapestries has been published during the last twenty years, but it is difficult to find comparative information concerning the technical aspects of construction. Most museum collections remain too small to provide a sufficient pool for comparative study. Exhibitions concentrating on textiles from a single center, such as the magnificent tapestry exhibition mounted in Bruges in 1987, are extremely rare, since they are very difficult and expensive to prepare and mount.

The use of scientific and physical investigations as tools of art history is a relatively recent development, and the answers that these investigations might offer are often of marginal significance in this field of research. Scientific and physical research is usually of interest only when it is interpreted and/or combined with comparative studies of a wide range of similar objects. The conservator often plays an indirect role in technical research. The investigation carried out on an object during

its stay in a conservation workroom and documented in the conservation report can form the basis for a separate technical analysis for purely comparative purposes. Even if a separate technical analysis has already been carried out by curatorial staff, the conservator still has to verify the technical details pertaining to the object before attempting any intervention. Usually the task of interpreting technical facts is left to curatorial staff members, who also take responsibility for collating and interpreting the art-historical documentation. It is desirable that conservators play a more active role in interpreting the technical data they themselves collate. The conservator works intimately with the objects and sometimes has the opportunity to study a textile minutely in the conservation workroom over a long period of time. Moreover, conservators often have background training in textile techniques.

One aspect of the physical examination of textile objects that is frequently undervalued is the role of the weaver or embroiderer in interpreting the artist's design. Both kinds of textiles involve, in most cases, the translation of a painter's figurative design into another medium. Not only must the weaver or embroiderer bring his technical skills to bear on rendering the design, he must also interpret that design. This is a subjective part of the process that can take different directions, so that the final appearance can vary according to the interpretation. Since there is never only one way that a design may be reproduced, several objects created from a single design might display differences in materials, techniques, and the skill of execution. Thus, in the creation of a tapestry or embroidery, the craftsman—who would have been bound by the choice and availability of materials—could embellish the original design by choosing certain colors and techniques, thereby introducing added textural and patterned effects. Therefore, when carrying out the technical analysis of any object, it is important to ask ourselves the whys and wherefores of the craftsman's choice of materials and techniques rather than simply to document the final result.

It is the design form of ecclesiastical embroideries and textiles that defines their role, not the techniques or materials with which they were made. Tapestries with religious themes, for example, would not be expected to differ in any major way from tapestries created for secular use, except in their design. Textiles associated with the rituals of the church often display images related to specific church traditions prevailing at a particular place or time. Studying these textiles can help chart changes in taste and custom.

It is usually seen as the conservator's task to make a technical analysis for research purposes that are directly related to conservation treatment. A technical analysis compiled with the sole intention of recording as much information as possible, to allow for deductions and conclusions of a more general kind relating to the historical aspects of construction, is normally considered to be outside the conservators purview. Yet the conservator is often the person who has the most opportunities to inspect an object thoroughly when it undergoes extensive and prolonged conservation treatment. Furthermore, a trained conservator with extensive experience and a practical knowledge of historical techniques is often better placed than anyone else to become aware of an object's similarities to other works and of the peculiarities in its composition, based on a feeling of sympathy with the craftsman's task of translating a design into textile. Since the conservator's primary task is to correct physical decay, it is the physical structure of any object that first attracts the conservator's attention. The design and iconography are also seen as important but of secondary interest to the conservator, whereas these aspects would provide the first line of interest to the art historian.

The physical analysis of embroideries and tapestries can also reveal something about the embroiderer and the weaver; the significance of this aspect for research has not yet received proper recognition. The techniques of both embroidery

and tapestry weaving are exclusively hand-controlled, which allows the creation of complicated figurative designs. The craftsman's complete control over his materials enables him to create especially subtle effects. This total control means that no two interpretations of a single design will be completely alike. The control of the craftsman over the design depends on a number of related factors, the foremost being the craftsman's own skill and training. The knowledge of trade secrets gave some craftsmen an edge in producing better-quality objects than their rivals could produce. The fact that trade secrets existed should indicate the value of technical analysis to researchers.

There is never one single way that a design should be interpreted. The types of materials available at the time of the object's origin influenced the way they were used. The embroidery technique known as *or nué* could work successfully only if good-quality gold thread was available. Use of such costly materials and design elements also reflected a wealthy client's taste for rich effects. Cheaper and less opulent effects were achieved by using other techniques and silk threads to execute the same design. Cheaper still would be a design embroidered with thicker, more widely spaced threads, using other types of stitches that could be executed more quickly. Similar examples illustrate different interpretations of tapestry designs based on the materials and techniques used. The particular materials and techniques chosen to interpret a design provide one of the keys to the whole cultural background of the period of a given textile. It is possible to deduce information about individuals, their position within the profession, their training and background, and the cultural milieu of their society, as well as the general standards of technology and level of trade. Of course, the same can also be deduced from a study of the artists' designs, but this field is already a focus of attention in art-historical research.

Many embroideries and tapestries remain of unknown artistic origin. Few embroideries were signed, and many tapestries have lost their distinguishing marks. Attribution, therefore, has to be made largely on stylistic grounds. This type of attribution is very broad, usually identifying a region or country. Closer study of the technical information pertaining to a given object might make more specific attribution possible. Attribution should not, however, be seen as the main objective of this research, but rather as part of an attempt to understand the object more fully.

Because of the scarcity of published technical information on documented tapestries and embroideries, it is difficult to evaluate the worth of this type of research. Before enough technical data can be assembled and collated to draw conclusions, a detailed comparison must be made of as many textiles as possible.

Although there are many surviving textiles, they are so widely dispersed as to make comparative studies difficult. No one single museum possesses enough examples of any particular type of textile to be able to draw reliable conclusions. In order for comparative research to have substantial benefits, the physical analysis method must be tackled simultaneously at a number of study centers, using the same approach and guidelines. It is vitally important that there be a general consensus on the question of what constitutes a complete technical analysis and that comparative research of this kind be carried out concurrently.

Biography	Stephen Cousens has been chief textile conservator at the Rijksmuseum in Amsterdam since 1980. A native Australian, his move to London in 1970 fostered the beginning of an interest in textile production that eventually led to his leaving a career with the Australian High Commission in order to devote time to hand-loom weaving. He studied tapestry weaving at West Dean College in Surrey and trained at the Textile Conservation Centre at Hampton Court Palace.

Conservation Maintenance of Tapestries at The Metropolitan Museum of Art, 1987

Nobuko Kajitani

The guidelines of our program are based on practices tested and proven in our museum over more than a hundred years of conservation maintenance. More recently developed "advanced" techniques will be adopted only when our ongoing experimental testing demonstrates that they are appropriate for our collection. In the meantime, we are pursuing our present program with vigilance. What follows is a discussion of our experience over the past twenty years. Together with my three previously published papers (Kajitani: 1979:45–63, 1977:161–180, 1973:97–103), it presents the testament we leave to be evaluated by our successors.

Our work on a tapestry begins by understanding the following factors affecting its condition:

1. The tapestry's aesthetic, technological, physical, mechanical, and chemical aspects; its conservation materials; its provenance and history
2. The tapestry's in-house history since its acquisition
3. The environmental conditions to which the tapestry will be subjected

Understanding the intrinsic quality of the tapestry, and evaluating its present condition with respect to the reasons why some areas are damaged while others are not, guides us in planning a conservation/preservation strategy, with due consideration given to the visual impact of the tapestry as an object displayed in the context of an art museum.

Once this preliminary evaluation is complete, the actual maintenance work that follows is nothing more than tedious and inconspicuous follow-through; it is merely an exercise in compromise and discipline. Some work must be done at once without any advance notice. Other work can be performed only over a long period of time. The most difficult work is the general care, which must be carried out daily, weekly, monthly, seasonally, yearly, by the decade, and by the century, according to an explicit program. One can easily dismiss or forget this type of work because it is difficult to distinguish whether this work has been done or needs to be done. Yet, in the long run, the effect of general care is significant.

Our concern for long-term preservation extends not only to the tapestry itself but to our conservation work as well. Any conservation materials we use must be of long-lasting quality and well suited to the intended treatment in terms of their aesthetic and functional features. The execution of our work should be done with the

utmost skill, producing a result that is unobtrusive. For the most part, previous conservation work on our museum's tapestries was performed with great technical facility. Nonetheless, for reasons to be discussed later, necessities sometimes arise that grant us the opportunity to renew previous conservation work in part or in total.

As is the case for museum collection management in general, maintenance of works of art in our museum is not yet fully established as the responsibility of professional conservators. For more than a hundred years, curatorial departments at The Metropolitan Museum of Art kept tapestries in their storerooms without enlisting a textile conservator to monitor the storage and exhibition environments and to carry out a regular maintenance program. As a result, these needs have been neglected. Even today, more than twenty years after the appointment of the first textile conservator in the history of our museum, the Department of Textile Conservation has not yet been given a mandate by all the curatorial departments to proceed with a comprehensive preservation program. We still encounter dust that has been rolled up with the tapestry in rather recent times and creases that have occurred in storage as a result of uninformed and insensitive handling procedures. Eventually, I hope that enforcement of a comprehensive preservation program—however time-consuming it may be—will allow our laboratory work to focus solely on the inevitable effects of the aging process rather than on damage caused by the neglect of daily maintenance and storage preparation in the museum.

Management

When a tapestry is being considered for acquisition, it is examined by curators and conservators. The examination report by the conservator generally includes:

1. A description of its physical state
2. An evaluation of its technical and material features as compared with related tapestries in our collection and elsewhere (In effect, we participate in the authentication of the tapestry.)
3. An evaluation of the significance of the tapestry within the context of our collection
4. Recommendations for storage, exhibition, and loan programs
5. A justification of the cost with respect to the quality of the tapestry and anticipated expenses for conservation work, exhibition preparation, and storage

If the curator proposes the tapestry for acquisition, he or she submits a proposal to the Acquisition Committee of the Board of Trustees. The process begins with a "dry run" meeting at which other curators also propose works of art in other media for acquisition. The director presides over the meeting, while curatorial and conservation department heads in attendance evaluate the works of art and scrutinize the proposals. The director then makes his choices and submits them in a formal presentation to the Acquisition Committee. If the proposed tapestry is selected by the director and approved by the Acquisition Committee, the tapestry is purchased for the collection.

After the paperwork is completed, the tapestry is brought to the Department of Textile Conservation, where it is prepared for photographing. A conservator handles the tapestry during the photography session. Black-and-white photographs, color transparencies, and slides are taken, showing the tapestry in full view as well as selected details. We then prepare the tapestry for storage and return it to the storeroom belonging to the appropriate curatorial department. It was formerly the general policy among curators to release us from further responsibility for the tapestry at this point. We are now in the process of changing this policy in order to continue comprehensive conservation maintenance of the tapestries while they are in storage.

The curatorial department responsible for any new tapestry sends general information on the acquisition to the Catalogue Department. Anyone who wishes to obtain information on a new tapestry will find its title, accession number, dimensions, material and technical information, provenance and dates, references, source, special exhibition and photographic information, and occasionally some scholars' remarks listed on a catalogue card. This information is brought up to date from time to time by the curatorial department.

Approximately fifty tapestries from our collection of three hundred are on exhibition (Standen 1985, Cavallo n.d.). At The Cloisters, a branch of our museum located on the Hudson River, there are approximately twenty medieval tapestries on exhibit, while the main building of the museum, located in Central Park, displays approximately thirty medieval and post-medieval tapestries. Of these, approximately twenty-five have been exhibited almost constantly and will continue to be on display for the foreseeable future (The Metropolitan Museum of Art Guide 1983).[1] The professional challenge confronting us is how to cope with such a situation.

Until recently, tapestries not on exhibition were stored in the curatorial departments' storerooms, which, as mentioned, were outside our jurisdiction. In the past, these tapestries were brought to us only when curators decided they were in need of conservation work, usually when they wished to exhibit them. Although other tapestries undoubtedly need our care, they do not necessarily come to our attention. Whenever we have been asked to participate in handling tapestries—for whatever the reason—we have taken the opportunity to conduct examinations, assess their condition, and plan a future work program. Today, the Department of Textile Conservation has garnered the initiative in the care of the tapestries belonging to the Medieval Art and American Art departments to the extent that we may lower the illumination levels, divert the drafts that come through doorways and ducts, and maintain a vacuum-cleaning program in the galleries.

The Conservation/ Preservation Work

Before the Department of Textile Conservation was established in 1973,[2] almost all of our tapestries had been wet-cleaned, restored, strapped, lined, and webbed for hanging before or after acquisition. These treatments have not only protected the tapestries in the past but have also relieved our generation of an enormous amount of work. Moreover, we are today in a good position to evaluate the merits and demerits of these fifty- to one-hundred-year-old conservation materials and techniques, as well as the environmental conditions to which the tapestries have been exposed over this period. These solid facts form the basis of our decisions about our conservation/preservation work.

Recording the Physical State

We maintain a file in the laboratory for each tapestry. A representative file is composed of:

1. A log sheet that records all relevant data
2. Photographs and slides of the tapestry, in full view and detail
3. Photocopies of the photographs, color-marked to indicate past and present restorations and notable features of the tapestry
4. A technical analysis record (Kajitani 1973:97–103), which includes:
 Dimensions
 Present
 Present original
 Reconstructed original

Condition
 Overall state
 Discoloration
 Damages
Technical information
 Weave structure
 Other techniques applied
 Materials
 Fiber (note analytical methods)
 Makeup
 Count
 Present (obverse) and original (reverse) colors
 Dye and mordant (note analytical methods)
 Condition of fiber in each color

5. A record of past conservation work
 On the tapestry
 Hanging method
 Storage method
 Conservation materials used

6. A record of present conservation work, if done
 General treatment record
 Washing record
 Technical work record
 Material record

7. A statement of environmental and physical conditions that must be met at exhibitions and loans

Washing[3]

It used to be the convention that after the last weft was woven, the completed tapestry was taken off the loom, technical faults were corrected, and details were retouched. It was then presented to the owner without undergoing wet-finishing processes normally applied to woolen fabrics manufactured for garments. The weavers considered the untreated tapestry as the final, presentable product. Today, it is very rare to encounter a tapestry that has never been subjected to rain, water, or washing. When we do come across such a tapestry, our guidelines prohibit washing and require soil-free preservation. The majority of tapestries have, however, been washed in the past. As their original dimensions, hand, and texture have already been significantly altered by the wet treatment, we allow them to be washed according to the dictates of our long-range conservation/preservation program.

In 1966, I had the invaluable experience of attending the last tapestry washing session performed by my predecessors according to the method developed in the 1920s. Both the tapestry—an early sixteenth-century work—and the washing facility underwent a seemingly long and careful preparation prior to the washing, which took place on a fine spring day under the roof of an open garage at The Cloisters.

In order to maintain tension on the tapestry throughout the washing process, strips of cotton muslin 30 centimeters wide were sewn around all edges of the tapestry. In the washing area, a set of washing screens framed with wood were assembled to accommodate the size of the tapestry. These were supported in midair by a scaffolding raised to a standing height. The tapestry was then spread out on the washing screens, and the muslin was nailed onto their frames to create tension on the tapestry. The tapestry was hosed thoroughly with cold tap water, followed by sudsing with a so-called "neutral" soap (more about this below) that had been boiled

in a bucket of water until thoroughly dissolved. A fine sea sponge was used to apply the hot soap solution. After each sudsing, the tapestry was hosed down with cold tap water. The sponging and rinsing were repeated until the washing was completed. Towels were used to absorb as much water as possible before the tapestry was left to dry stretched on the screen. The result of the washing was considered successful: the colors brightened and the hand softened (because of the high alkalinity in the soap), the dimensions remained unchanged, and the texture retained its flat and even level (because the tapestry had been kept under tension throughout the washing and drying).

In 1972, fragments of a Unicorn tapestry were brought to me to be reworked.[4] The fragments had been wet-cleaned at the end of the 1930s, possibly by the method described above. After considerable thought, we decided to wet-clean them using the rare opportunity provided by the fragments' removal from forty consecutive years of exposure in the gallery environment at The Cloisters. With a tapestry that has been on exhibition for so long a time, one can usually expect a pH of 4 or lower in the first rinse water. In this case, however, the first ten minutes in rinse water—pH 6.8, approximately 25 °C, demineralized—yielded an unusually high pH of 6.3 without much "browning" of the water. In the second rinse, a series of bubbles began to pop up from the tapestry into the water, and the tapestry's pH rose even higher to 10.5. After one detergent wash—pH 7.5, approximately 25 °C—for the removal of soils, a prolonged rinsing was repeated until the tapestry's pH was lowered to a neutral range of pH 6–7.

Under the method developed in the 1920s, tapestries were washed with a commercially made soap that was the best available at the time. The manufacturer classified it as "neutral soap" in industrial terminology. This was misleading; it meant that the soap contained the least amount of free alkali, not that it was neutral in pH. The soap's pH was, in fact, between 10 and 11, the range that the tapestry registered during the recent washing. The high alkalinity of the soap used for the previous cleaning must have removed more than just soil on the tapestry surface; it must have also removed the oxidized surface of the five-hundred-year-old fibers. In addition, we surmise (1) that the tapestry did not receive a thorough rinsing because it was not completely submerged in the water (plastic sheeting was not yet available); (2) that the water was untreated (demineralized water was not available); and (3) that the soap, which was made soluble by hot water, was afterwards rinsed down by cold water (hot water was unobtainable in large quantities at that time). All of these factors must have contributed to the residue of soap that remained on the tapestry, conceivably for fifty years.

But why did our first rinse water not turn brown? Was it because the tapestry had not oxidized? Did the alkalinity in the residual soap actually slow down the rate of oxidation of the tapestry? Is the theory of alkaline reserve really working here? If so, what type of alkalinity is appropriate to use as an alkaline reserve for proteinaceous fibers (Rice 1970b:58–61; Crafts Council 1983)?

Today, we can accomplish wet cleaning effectively and efficiently with our greatly improved facilities: a large indoor washing floor (though not large enough to accommodate *all* tapestry sizes), stainless steel support screens, a ready supply of temperature-controlled demineralized water and a good drainage system, a detergent made from saturated fatty acids with a pH of less than 8, a pH meter, and enough manpower to accomplish the entire operation in a much shorter time (Kajitani 1979:54–57).

Restoration

Various methods have been applied over the past five hundred years to restore the pictorial surfaces of tapestries. We have chosen a combined approach of traditional and more recently accepted restoration/conservation methods (Kajitani 1979:57–58). They are as follows:

1. Reweaving: This method is applied to areas where enough traces of the original yarn remain to indicate the design and where the warps and wefts remain strong enough to tolerate the process.

2. Sewing down loose warps and wefts onto full or local backing/support fabrics: This method is applied to areas where no indication of the original yarn remains or where the warps and wefts are too weak to tolerate reweaving. In this case, the color of the support fabric should blend well with the surrounding areas.

Although a single restoration method is generally preferable, we use both methods in combination on some tapestries where the causes of deterioration vary from one area to the next. In such cases we first complete reweaving and then we stabilize the loose warps and wefts by sewing them onto the support fabric.

In working with these restoration methods, we apply the following guidelines and considerations:

1. Old restorations and reweavings are removed if they are pictorially, chromatically, structurally, or functionally obtrusive and do not blend well with the surrounding areas. We sometimes copy the pictorial effect in old restorations if they can be considered direct copies of original details—that is, if they seem to have been applied when traces of the original yarns were still present.

2. The longevity of restoration materials must be proven.[5] We have witnessed the fact that virtually all silks used since the early twentieth century have deteriorated more rapidly than any other fibers. Consequently, we no longer use silk when longevity is required. In its place, we use mercerized cotton.

3. The restoration materials must demonstrate sufficient colorfastness with respect to light and water (Trotman 1984). The colors of the original tapestry materials may actually fade more readily than the colors of the restoration materials, adding another consideration to our preservation plan.

4. However hard we try to approximate the texture of the original yarn, modern woolen yarn will never be identical to the original. The surface of the original yarn has oxidized and deteriorated to a degree that no new yarn can simulate. Furthermore, the type of yarn used for weaving cannot be used for reweaving because it cannot withstand the friction caused by the reweaving process. The selection of the reweaving yarn is, therefore, based primarily on the yarn's smoothness and strength to withstand the strain of reweaving. Viewed from a distance, it is the colors that most significantly affect the visual impact of the tapestry; the texture differences, by contrast, are almost indiscernible.

5. In selecting colors, we simulate the colors—often faded—on the front of the tapestry, not the original colors visible on the back.

6. The compactness of the reweaving surface should likewise simulate the texture of the tapestry in its existing condition.

When these guidelines are followed, rewoven areas come out lighter, more variegated, and sparser—when viewed up close—than the tapestry as originally

woven. Yet, when viewed from a proper distance, the restoration will be inconspicuous.

In restoring brown colors that render overall demarcations and design elements, we choose a chroma compatible with each surrounding area. Inevitably the choice will be more variegated and lighter than the original brown: If only one shade is used in a tapestry throughout the restoration, it will flatten out the three-dimensional pictorial impact. If the original brown color is simulated in a tapestry that is faded overall, the restoration will stand out too prominently because tannin/iron browns do not fade.

With respect to both the dyeing technique and the needlework method, it must always be kept in mind that the restored tapestry must present a naturally uneven color in order to approximate the surface of the time-honored original. It must not reflect the sort of flat and even industrial look produced for today's standards of technological excellence.

Hanging Preparation

In the past, nearly all tapestries were equipped with a set of straps to help support the weight, a lining to prevent soiling from the back, and a webbing and a slat to facilitate hanging. When the tapestry was to be exhibited, the webbing was nailed onto the slat, and the slat was hung with wire held by S-hooks that were hooked onto the U-shaped molding on the wall. This system has been used in our museum for a long time, and we still consider it the most effective method of hanging tapestries (Kajitani 1979:58–59).

When my predecessors noted that the tapestries imported from the Old World had been strapped and lined with linen cloth, they assumed that linen was preferred to cotton, and they conscientiously followed this European tradition, importing the linen goods from abroad. Actually, linen was used in Europe not by choice but by necessity because it was the only cloth available domestically. As industrialization of textile manufacturing progressed and labor costs soared, linen industries began to economize by using inexpensive, harsh chemicals to hasten the process of extracting fibers from the flax stalks, instead of following the time-consuming and labor-intensive natural retting process.

The linens used for conservation work in the 1950s were probably made of such industrially processed cloth. This explains why these linens have, after only thirty years, gone to shreds on those tapestries that have been hanging in the galleries continuously during this period. These deteriorated linens include light-weight canvas linings sewn with shirring to the back of the tapestries, sheer drapery fabric used to create a surface texture for mounts, and heavy basket-weave cloth used as borders. By contrast, the linen linings and webbing tapes used during the eighteenth and early nineteenth centuries are still in good condition.

Jute webbing tapes and silk sewing threads likewise break down, usually within a twenty-year period. Some have deteriorated even while the tapestry is passively maintained in storage. Jute, being composed of lignocellulose, which inherently breaks down rapidly, should never be used as a conservation material. If jute is found to be part of a tapestry, the utmost in physical and chemical preservation methods should be carried out. Silk manufactured today is also unreliable. Not only is it processed through harsh treatment, which weakens the fiber, but certain of its qualities have changed genetically in ways that have shortened its longevity. Both linen and silk processed by today's standards cannot, therefore, be regarded as long-lasting conservation materials. Unless we find naturally processed fibers—which would be very costly in today's market and probably not reliable—there is no reason to use linen and silk as conservation materials. Also, while these fabrics must be im-

ported, cotton, which does not require harsh processing, is produced in abundance here in the United States. The search for better conservation materials is our foremost concern.

In 1966, we began to use cotton cloth—prewashed for dimensional adjustment and sizing removal—for strappings and linings; cotton or synthetic fiber webbings for hanging; and cotton, linen, and synthetic fiber threads for sewing. For hanging smaller, lightweight tapestries, Velcro tape is now used. Additional security tabs fasten the slat to the webbing to guard against theft. The wood selected for the slat should be of the type that produces the least amount of acidic resin; two coats of polyurethane resin are applied to seal in the wood resin. The functional longevity of these conservation materials cannot be properly evaluated until the years 2020 to 2045 (Kajitani 1979:57–59).

Hanging Operation

During the hanging operation, the safety of the tapestry as well as that of the workers should be ensured. The hanging of a medium-sized tapestry requires two ropes, each with a pulley and a hook; two high rigs; and at least five workers—two on the rigs, two to handle ropes, and one to direct the operation and watch out for the safety of the tapestry and the workers.

The operation usually proceeds in the following manner:

1. The area is freshly cleaned, including the floor in front of the wall on which the tapestry is to be hung.
2. The floor is covered with polyurethane film or paper, on which the tapestry is unrolled and spread out completely flat, with its top edge parallel to the hanging wall.
3. The webbing sewn at the top of the tapestry is then tacked onto the slat. To ensure that the tapestry will hang without a flare, the tapestry should be laid flat, in alignment with the position in which it will hang on the wall, during this part of this procedure.
4. The tapestry is then temporarily rolled up from the bottom on a full-length tube in preparation for the next procedure.
5. Next, the tapestry is unrolled to form a stack of pleats approximately 30 centimeters wide. The slat end should wind up on the floor toward the wall, away from the stacked, pleated tapestry.
6. Screw eyes are fastened to the slat.
7. The hanging wires, cut to the approximate length, are securely attached to the screw eyes. The free ends of these wires are attached temporarily to the lifting ropes while the tapestry is maneuvered from the floor to the hanging position on the wall, as described in the next procedure.
8. Next, the pleated tapestry is moved across the floor to the wall on which it is to be hung by sliding the polyethylene film on which it rests. If the above procedure has been followed, at this point the back of the tapestry should face the wall.
9. Rigs are positioned in front of the places where the two wires with S-hooks are to be mounted on the wall molding.
10. Pulleys are then hooked onto the molding, aligned with the position of the screw eyes on the slat.
11. The hook at the end of each rope running through the pulleys is attached to each hanging screw eye while a worker holds the other end of the rope. The tapestry is now ready to be lifted.

12. As the rope is pulled, the slat rises, and the pleats unfold from the floor as the tapestry ascends the wall. This maneuver should proceed slowly, steadily, and absolutely evenly until the tapestry approaches the predetermined hanging position.

13. At this point, with the ropes under tension, the hanging wires are adjusted to the correct length and an S-hook is attached to the end of each wire.

14. The S-hooks are then hooked onto the molding directly above the screw eyes.

15. The tension on the ropes can now be released so that the position of the tapestry can be inspected. It should hang slightly away from the wall, absolutely flat without a flare. The center vertical and center horizontal lines of the picture should align to render the focal point from a good viewing position. Pulling on the ropes will produce a slack on the wires so that the S-hooks can be repositioned and the wire lengths adjusted if necessary. The S-hooks are then fastened back onto the molding and the ropes released for another inspection.

16. When the tapestry is hung in the desired position, the hooks, ropes, and pulleys are removed, and the rigs are taken away. The operation is complete.

The tapestry can be removed from the wall by reversing this procedure.

Before the tapestry is in place, environmental conditions must be adjusted for climate and the velocity and direction of air movement. After the installation of the tapestry, the level and distribution of illumination must be adjusted. To monitor these factors, as well as the calculated visitor traffic pattern, daily inspection is necessary.

Housekeeping

All tapestries on exhibition share a degree of physical strain, oxidation, photodegradation, and chemical disintegration. To lessen these problems, we monitor the physical and chemical factors discussed below (Kajitani 1979:49–52).

1. Climate (Kajitani 1977:170–171, 1979:49)

We maintain a stable relative humidity (45–50%) and a steady temperature (optimally as low as possible and not exceeding 23 °C). The placement of tapestries in a gallery is calculated to keep them away from the drafts caused by passers-by and air ducts. The air movement necessary to maintain a conditioned climate must be monitored constantly so that it does not reach the surface of the tapestries at a velocity of more than 3 mpm. A velocity meter helps us to monitor this situation and to convince engineers to divert the air movement if necessary.

2. Illumination

We use ambient illumination, not spot-lighting (Kajitani 1977:171–173; 1979:49–50). Although all dyed colors fade when exposed to light, the following chart provides guidelines for the maximum light level permissible when tapestries are on exhibit. When they are not being viewed, tapestries should be kept in the dark at all times.

Dyes	Color Intensity	Maximum Light Level	Light Effect
		(the lower the better)	
Indigo	Dark shade	80 lux or less	Fairly insignificant
Indigo	Light shade	30 lux or less	Fades
Madder	Dark shade	50 lux or less	Yellow cast fades
Madder	Light shade	30 lux or less	Fades
Insect red	All shades	50 lux or less	Blue cast fades
Brazilwood	All shades	0	Fade completely
Archil	All shades	0	Fade completely
All yellows	All shades	0	Fade completely
Tannin	All shades	80 lux or less	Accelerate oxidation

(Green, which is composed of a yellow dye and indigo, should be illuminated at 30 lux or less.)

Hours of illumination are restricted to visiting hours only, amounting to approximately sixty hours per week. Most tapestries are provided with ambient illumination by incandescent light at the maximum level of 80 lux (Kajitani 1979:47-48; Masschelein-Kleiner 1979:29-40). Some galleries have exposure to daylight, though only at a safe distance from any tapestry-hanging wall. Ultraviolet rays are kept to less than 75 lumen (Thomson 1978).

3. Contaminants

Chemically undesirable materials such as wood and plaster should be eliminated from the surroundings if possible. If the presence of these materials is inevitable, then a buffered, acid-free paper is used as underfacing to protect the tapestry.

Each tapestry on exhibition is vacuumed through a screen on the hanging wall once or twice each year, depending on its physical location. A water receptacle in the vacuum cleaner traps the lightweight dust so that it cannot fly back into the air.

4. Physical damage caused by incidental touching

Barrier ropes and platforms are situated at a distance greater than an arm's length.

5. Insect attack

Insect attack can occur in the gallery during any season of the year. Open doors, house plants, cut flowers, and visitors facilitate insects' entry. Our present strategy against insect attack is based on early detection by constant overall inspection of all tapestries on exhibition and in storage.

6. Length of hanging

Although the following does not apply to all cases, our guideline is that a tapestry may hang for a maximum of six months on exhibition. Observance of this rule is particularly important with respect to tapestries woven with silk threads.

Storing

Tapestries are kept in a storeroom for the sake of their preservation. Yet, until recently, the tapestries were simply left there on deposit because they were not on exhibition; i.e., no professional measures were taken for their protection. Before our involvement, after the tapestry was removed from the exhibition wall, it was spread out on the unswept floor, perhaps vacuum-cleaned, then rolled up around the slat from top to bottom, tied, and placed in the storeroom, sometimes with and sometimes without a wrapping. When "needed"—that is, for exhibition—the tapestry was taken to the repairer, who dusted, washed, mended, and prepared the tapestry for hanging (Fig. 1).

Figure 1, above. A storeroom, from an old scene.

Figure 2, top. A cradle for storage.

Figure 3, top right. A cradle on a storage rack.

In 1973, after a decade of diplomatic urging, one of the museum's curatorial departments for the first time assigned the task of post-exhibition conservation work to textile conservators. This job includes removing the slat from the tapestry, vacuum-cleaning the tapestry, examining it for the record of its technical/material condition, and making recommendations for its conservation/preservation. The tapestry is then rolled up in the direction of the warp, provided with a protective storage wrap, and returned to the curatorial department for storage.

In 1979, we had an opportunity to design a tapestry storage/transport case. Its purpose was to protect the rolled tapestry from the soiling and oxidation that could take place even in the storeroom and from the damage that could occur during handling. This design features a tube on which the tapestry is rolled, encased in an outside cradling tube that serves as a storage/transport case (Fig. 2). When it is stored, the cradle rests on notched brackets (Fig. 3). When it is transported to a gallery, the cradle, with the tapestry inside, is placed on a cart installed with brackets. When the tapestry is shipped out on loan, the cradle is supported in a crate, and the borrower is asked to transport the tapestry to the gallery in the cradle.

In 1984, a comprehensive preservation program designed by the Department of Textile Conservation was for the first time adopted by the Department of American Art. Under this collection management system, the Department of Textile Conservation assumes the operation of the storeroom, reporting to the curator on all activities concerning each tapestry. We are thus able to practice our comprehensive conservation/preservation program thoroughly and effectively for all the textiles of the department. Under our complete care, each of the twenty-one early twentieth-century American tapestries was rolled and placed in an individual cradle, then stored in a newly organized, air-conditioned storeroom (Fig. 4). Ironically, there are tapestries from earlier periods that need our serious attention more than these more recently woven ones.

Over the years, curators from other departments have submitted our storage design to the administration of the museum. As a result, in 1987 the Department of Medieval Art became the second department to let us administer its tapestry storeroom. In the initial stages of the conservation/preservation program, all of the tapestries in the department underwent a material/technical examination and were given basic storage preparation. The physical storage facility has not yet been constructed. Still, even with only these interim measures, the storage conditions for these tapestries have improved for the time being. The provision of a proper storage space and a suitable environment will follow in the future.

For later European tapestries, which constitute the major part of our tapestry collection, the topic of comprehensive preservation occasionally surfaces for discussion. To date, however, our department has not been given authority over the maintenance of these tapestries.

Figure 4. Cradle storage system.

However long it might take to establish trust between the curators and administrators in the future, we hope to realize full implementation of our comprehensive conservation/preservation program for all the museum's tapestries by the year 2000.

Notes

1. In response to the author's question at this point in the presentation, the majority of participants recommended that even the Unicorn tapestries (37.80.1–6) in The Cloisters should be exhibited in rotation.

2. Mrs. van Godin restored tapestries in the 1930s, including the Unicorn tapestries; Mrs. Burke restored tapestries and textiles between the 1940s and 1966; and Mrs. Matilda Sullivan restored tapestries and textiles between the 1950s and 1968. The author began conservation work at The Metropolitan Museum in 1966. The present textile conservators are N. Haller, E. Phipps, A. Murao, C. Giuntini, T. Kane, F. Matsubara, C. Carr, S. Hawkes, M. Sato, K. Meyerhoff, R. Roberts, and E. Brescia. Textile restorer/conservators worked in the Department of Conservation until the Department of Textile Conservation became independent in July 1973.

3. James W. Rice, a series of articles on textile conservation science published in *Textile Museum Journal*, 1962, 1963, 1964, 1966, 1967, 1968, 1969, 1970, and 1973. Fulton, *Applied Science for Drycleaners* (Silver Spring, Md., 1951). Kajitani, "The Preservation of Medieval Tapestries" San Francisco, 1979).

4. Accessions 38.51.1 and 2 [The Metropolitan Museum of Art], "The Unicorn is Tamed by the Maiden," wool and silk. In fairly good condition; fragmentation by cutting, not by deterioration. Left, 1.74 m x 0.65 m; right, 1.94 m x 0.66 m.

5. There is no longevity test method specifically designed for conservation materials in the textile conservation field. We examine conservation materials only by our professional sense and our knowledge of manufacturing processes. It is important to have references: The study of old fibers in museum textiles and old conservation materials found with museum textiles is essential. The establishment of testing methods for longevity is needed.

References

Cavallo, Adolph S.

n.d. *Medieval Tapestries in The Metropolitan Museum of Art*. New York: The Metropolitan Museum of Art. Forthcoming.

Crafts Council

1983 Water, Acidity and Alkalinity. *Cleaning*. Book 2. Crafts Council Science Teaching Series. London: Crafts Council.

Fulton, George P.

1951 *Applied Science for Drycleaners*. Silver Spring, Md.: National Institute of Drycleaning.

Kajitani, Nobuko

1973 Technical Notes, (to accompany Vera Ostoia's essay, Two Riddles of the Queen of Sheba). *The Metropolitan Museum of Art Journal*. Vol. VI. New York: The Metropolitan Museum of Art.

1977 Care of Fabrics in the Museum. *Preservation of Paper and Textiles of Historic and Artistic Value*. Advances in Chemistry Series 164. Edited by John Williams. Washington, D.C.: American Chemical Society.

1979 The Preservation of Medieval Tapestries. *Acts of the Tapestry Symposium, November 1978*. Edited by Anna G. Bennett. San Francisco: The Fine Arts Museums of San Francisco.

Masschelein-Kleiner, Liliane

1979 Dyeing Techniques of Tapestries in the Southern Netherlands during the Fifteenth and Sixteenth Centuries. *Acts of the Tapestry Symposium, November 1978*. Edited by Anna G. Bennett. San Francisco: The Fine Arts Museums of San Francisco.

The Metropolitan Museum of Art

1983 *The Metropolitan Museum of Art Guide*. Edited by Kathleen Howard. New York: The Metropolitan Museum of Art.

Rice, James W.

1962 General Chemical and Physical Structural Features of the Natural Textile Fibers. *Textile Museum Journal*. Vol. I, No. 1. Washington, D.C.: The Textile Museum.

1963a Classification of Fibers Found in Ancient Textiles. *Textile Museum Journal*. Vol. I, No. 2. Washington, D.C.: The Textile Museum.

1963b The Conservation of Historic Textile Colorants. *Textile Museum Journal*. Vol. I, No. 2. Washington, D.C.: The Textile Museum.

1964 The Characteristics of Soils and Stains Encountered on Historic Textiles. *Textile Museum Journal*. Vol. I, No. 3. Washington, D.C.: The Textile Museum.

1966a The Wonders of Water in Wetcleaning. *Textile Museum Journal*. Vol. II, No. 1. Washington, D.C.: The Textile Museum.

1966b Characteristics of Detergents for Cleaning Historic Textiles. *Textile Museum Journal*. Vol. II, No. 1. Washington, D.C.: The Textile Museum.

1967 Drycleaning of Fine and Fragile Textiles. *Textile Museum Journal*. Vol. II, No. 2. Washington, D.C.: The Textile Museum.

1968 How Humidity May Affect Rug, Tapestry, and Other Textile Collections. *Textile Museum Journal*. Vol. II, No. 3. Washington, D.C.: The Textile Museum.

1969 Requirements for Bulk Storage Protection Against Insect Damage. *Textile Museum Journal*. Vol. II, No. 4. Washington, D.C.: The Textile Museum.

1970a Acids and Acid Salts for Textile Conservation. *Textile Museum Journal*. Vol. III, No. 1. Washington, D.C.: The Textile Museum.

1970b The Alkalies and Alkaline Salts. *Textile Museum Journal*. Vol. III, No. 1. Washington, D.C.: The Textile Museum.

1973 Solutions and Other Mixtures for Cleaning and Conservation of Textiles and Related Artifacts. *Textile Museum Journal*. Vol. III, No. 4 Washington, D.C.: The Textile Museum.

Standen, Edith A.

1985 *European Post-Medieval Tapestries and Related Hangings in The Metropolitan Museum of Art*. Vols. I and II. New York: The Metropolitan Museum of Art.

Thomson, Garry

1978 *The Museum Environment*. London: Butterworth.

Trotman, E.R.

1984 *Dyeing and Chemical Technology of Textile Fibres*. Sixth edition. New York: John Wiley & Sons.

Biography

Nobuko Kajitani has served as administrator in charge of the Department of Textile Conservation at The Metropolitan Museum of Art in New York since 1966. She is also Adjunct Professor of Conservation at the Conservation Center, Institute of Fine Arts, New York University. She was educated in her native Japan followed by specialized museum textile training in the United States. Her work on museum textiles emphasizes long-range preservation of the inherent and intrinsic qualities of the object. She is a specialist on the history of fiber and fabric technology; her published works include papers on pre-Columbian, Coptic, and Middle Eastern archaeological fabrics.

Tapestries: Conservation and Original Design

Karen Finch

Tapestries fascinated me long before I ever saw one. I read about how they were used to make cold and drafty castles comfortable. When I saw pictures of tapestries with scenes from history, I imagined how they would change and move and give an illusion of life. Then I saw a real tapestry at the National Museum on a school trip to Copenhagen; I was disappointed because the colors were dull and the designs distorted.

Many years later, colleagues in the field of paintings conservation told me they disliked tapestries because "the drawing is so bad." By then I had come to realize that these colleagues had probably only seen tapestries that were so distorted by repair that they bore no relation to their original design. I would show them what had happened and how to understand the damage in the context of what was left. Taking these considerations into account, I explained to them that, as with paintings, there are good and bad tapestries.

My work on tapestry conservation and eventually on the training of tapestry conservators grew out of my training as a weaver and designer at Kunsthaandvaerker-skole [art school] in Copenhagen. My approach is firmly based on respect for the design and the artist's way of seeing things, as influenced by the familiar images and fashions of their day.

The Kunsthaandvaerkerskole was housed in the Museum of Decorative Arts, the staff of which taught me their views on conservation. Their objectives followed the traditions established in Sweden since the beginning of the twentieth century: to conserve only what was left and not to add missing parts.

When I came to England and a position at the Royal School of Needlework, I discovered, first of all, that this view was not universally held. Second, I discovered the strong embroidery frames that allowed all large textiles, including tapestries, to be kept safe and neatly rolled up during the lengthy process of repair. And I also began to discover how tapestry designs might get distorted.

Factors Causing Distortion of Design

Distortion of a tapestry design can result from:

1. Uncovering only very small areas for each mending session
2. The difficulty of relating the parts of a design being treated with those parts that remain rolled up
3. Working without photographs to consult

4. The use of unsuitable materials, such as soft embroidery wools, instead of the hard, lustrous, worsted wools of the original

5. Anchoring the yarns used for the repairs in the sound part nearest to the damage, thus blurring the design outlines

6. The use of unrelated patches from another tapestry

7. The reweaving of damaged areas to conform with current views on beauty and style

8. The use of dyestuffs that demonstrate a vastly different fading pattern and light reflection from the original

9. Working on tapestries only during the intervals between better-paid commissions

10. The boredom engendered by darning the fabric while knowing nothing of the design

11. The diminution of interest in the work resulting from these combined factors

At Hampton Court Palace, the set of six Mortlake tapestries known as the Solebay tapestries—which were repaired at the turn of the century—illustrate these effects. Some show large areas of sky visibly repaired in rectangular shapes on separately stitched warps (Pl. 25).

I can imagine how such disfiguring work came about. The repairers might simply have been trying to relieve the boredom of the work by marking out the area they were going to complete as a target for each day's or week's work. They could not have realized how much damage they were doing to the design as a whole because they would not have been able to appreciate the fact that the vast areas of sky—now just faded and broken silk—were filled with faint details. These subtleties were no longer discernible at close range; they could be seen only at a distance when the tapestry was hanging.

Factors Causing Damage to the Fabric Dyestuffs

Tapestries are works of art, and, like all works of art, they last only as long as their materials. The first part to suffer is, sadly, the one the designers depend on most, namely the dark colors—the browns and the blacks. These colors were usually darkened with some form of iron. Anyone who has worked with natural dyestuffs is aware of the loss of "body" from yarns mordanted with iron, and they will readily understand why the dark colors fall out.

From early records we know that dyers' guilds and merchants introduced quality-control regulations governing the use of dyestuffs and the dyeing process for the purpose of protecting their trade. The regulations varied from country to country. In London, the Dyers' Guild obtained its royal charter in 1471, and in Germany and France there were regulations concerning the division of fine and plain dyers before 1600. In Germany, the plain dyers formed a guild, while fine dyers regarded themselves as artists and therefore as independent and responsible only to themselves (Nielsen 1972).

By about 1700, the rules governing fine and plain dyers were strict—especially in France, where a fine dyer was not allowed to keep logwood, orseille, or Spanish green (ferrous sulphate) on his premises and could keep only small quantities of gallapples, sumach, and copper water (copper sulphate) used for darkening colors. To ensure long-lasting yarns, black color was produced by dyeing red on blue or blue on red.

The dyeworks that supplied tapestry workrooms employed a dyer for each color; dyers of blue were allowed to work together with dyers of red, as long as each stuck to his own color.

Both fine and plain dyers were allowed to use walnut shells, bark, and leaves; both were prohibited from using alder bark (*Betula alnus*), brazilwood, wild saffron, iron filings or other waste from the smithy, or old sumach solutions from making leather. All other practices not expressly allowed were forbidden.

I have tried to correlate the dark areas of the tapestry to the prevailing rules concerning dyestuffs, but the bad condition and sometimes the absence of brown and black colors make it hard to believe that dyers actually obeyed these regulations. The fact that merchants had the knowledge and means of testing dyestuffs with chemicals since the Middle Ages does not seem to have influenced this situation.

Bleaching prior to dyeing light colors was a major cause of damage to silk, especially when the sericin was removed with chemicals instead of soap. Using chemicals to remove the sericin was generally the practice in England. These two factors together probably account for the bad condition of the silk parts of the Mortlake tapestries.

Wear and Tear

Gothic tapestries suffered in transport from castle to castle as well as from being nailed up and taken down again. Given sound climatic conditions, however, tapestries survived even while nailed to battens fixed to unplastered walls.

Dampness and the microclimate existing behind pieces of furniture could cause severe damage and might, within months, weaken or destroy the linen lining and straps supporting the tapestry and eventually the tapestry itself. Wool is very resistent to dampness but would succumb to mildew.

Factors Causing Damage to both Design and Fabric

Historically, maintenance practice included repeated reweaving of dark outlines and other dark parts of a design. On a tapestry of the Esther series at the Victoria and Albert Museum, we found evidence that the dark outlines had been rewoven at least three times. One reweaving had introduced thicker yarns, and in all three the color had altered after the reweaving so that—including our repair—there were four unintended effects modifying the largest group of colors making up the design.

Among the factors causing damage to both design and fabric were deliberate cuts or other incisions: The tapestry that Polonius hid behind could not have been the only one to suffer from accidental vandalism! In later times, tapestries were often cut down to fit around windows and fireplaces and to cover doors in order to make houses warmer and more comfortable. Sets of tapestries were split up and sold when their style went out of fashion. Some of their new, less fashion-conscious owners took good care of the tapestries, while others cut them up to fit smaller spaces or to serve as curtains or as room dividers slung over a rope.

Some tapestries fared even worse. The Lady and the Unicorn series, now at the Musée Cluny, had been used to cover greenhouses. The lower part of these tapestries had to be rewoven where they had rotted. The new yarns have since faded.

Tapestries also suffered from changing preferences and attitudes. A Brussels tapestry of the sixteenth century belonging to the Worshipful Company of Goldsmiths showed Anthony and Cleopatra with her leg in his lap. The tapestry had been altered to conform to the nineteenth-century views on decorum. The weaving of Cleopatra's leg was removed and the space rewoven with yarns dyed to match Anthony's crimson garment. Alas, the nineteenth-century dyestuffs did not have the enduring quality of the original dyestuffs, and the leg has in the meantime reappeared as a patchwork in shades of pink (Pl. 26).

Until the end of the eighteenth century, the people who performed these repairs were likely to be tapestry weavers. The tapestry workshops offered after-sales

Until the end of the eighteenth century, the people who performed these repairs were likely to be tapestry weavers. The tapestry workshops offered after-sales maintenance service to their patrons in the hope that this might lead to the commission of new tapestries.

The work of these artisans is difficult to detect because they knew how to use techniques and dyestuffs similar to those of the tapestry they were repairing. At Coventry Town Hall, a pre-Reformation tapestry was adapted to reflect Protestant values by cutting away a rosary. The space was rewoven with wools dyed with the same dyestuffs, though a linen warp was inserted in place of the original warps.

In the nineteenth century, when tapestries had gone out of fashion as wall covering, it became progressively more difficult to get repairs done on those that remained in their original houses or in the new museums that began to proliferate. Because tapestries had lost their value, repair had to be cheap and therefore performed in some cases by unskilled hands, often with disastrous results (Textile Conservation Centre 1984).

Revaluation of Tapestries

In 1876, the revival of interest in tapestry weaving led to the creation of the Royal Windsor Tapestry Works, where low-warp looms and the new synthetic dyestuffs were used. The pattern of fading and light reflection of these new dyestuffs turned out to be totally different from the natural dyestuffs. When the Works closed after about nine years, some of the weavers may have taken up private tapestry repair using these same synthetic dyestuffs. This would account for the repairs on medieval and later tapestries that changed color or faded away within a relatively short time.

At the Merton Abbey workrooms set up by William Morris in 1881, only natural dyestuffs were used. The weavers were very innovative and attempted realism in their weaving of grass and pebbles. This may be seen in the Ship tapestry by Edward Burne-Jones at the Birmingham Museum and Art Gallery. The tensions created by these methods cause this narrow tapestry to twist when hung (Pl. 27; Fig. 1 a,b).

Natural dyestuffs were also used in the American workshop set up at the turn of the century. Here "Gothic" tapestries were produced using yarns made from the right type of wool, yet wrongly spun. This workshop's designs—taken from the

Figure 1 a (front), b (back). Ship tapestry (see Pl. 27). Tensions set up by the naturalistic weaving of the grass cause this narrow piece to twist when hung.

Conservation and Design of Tapestries

Conservation

At the Royal School of Needlework, I had discovered that the original designs were mostly still discernible, even when they were hidden beneath layers of disfiguring repairs. From 1954, when I joined the Art Work Room (soon renamed the Conservation department) at the Victoria and Albert Museum, I put this knowledge into practice by taking out unsightly repairs.

The first big piece I did was a failure. It involved joining the two halves of a tapestry that had been cut from top to bottom. I rewove the join laboriously, warp by warp; however, despite the skill I had by now acquired, the join could very easily be seen. I realized that the time it took to reweave damaged areas of a tapestry was justifiable only if the finished result would not attract attention.

I began to spend lunch hours in the library and in the galleries examining the repairs that were generally unacceptable and correlating them with repairs that had been done by skilled tapestry weavers since about 1890. Most of these repairs would have been satisfactory had the weavers used the right materials; however, because the yarns had faded or changed color, each repair stood out and drew attention away from an appreciation of the design itself. I discovered that it was easier to overlook simple darning than it was to overlook more elaborate types of repair, especially when these suffered from the defects engendered by the repairer's way of viewing things, as dictated by the fashions of the day. Views on beauty and style change with the philosophy of each era and can never be recaptured. I recall seeing a medieval tapestry where one of the characters had been given new eyes that reflected the look of a film star of the 1940s. The reweaving of missing parts is best discouraged, however tempting it may be for the repairer to demonstrate his or her skill.

The next step was to work out techniques to overcome the various problems, including the problems caused by the fact that the value of tapestries was set by dealers who considered darning and reweaving as the only acceptable repair technique. They felt that patches on the back proclaimed that the tapestry had been repaired. This was an important consideration in the climate of the 1950s, when the conservation ethics now generally accepted were in their infancy and when it was still the custom to drop out rotten silk and other damaged materials to make room for reweaving.

I felt that using linen patches on the backs of the tapestries would enable us to preserve what was left of both color and design and still make the tapestry safe to hang. I also wanted to restrict the use of foreign material on the front of the tapestry so that inevitable fading and color changes would be less noticeable and cause minimal interference with any part of a design, including effects seen only at a distance. Also, I intended that *our* repairs should be easy to remove in case they too became unsightly over time.

This approach represented a radical break with the tradition of tapestry repair practiced in England until that time; however, it was accepted by the Keeper of the Textile department, who encouraged me to proceed. The first tapestry to receive this treatment was a French work with a foreground design of a tree and a pond. Vast areas of sky had been reworked repeatedly, with one repair on top of another. I began by washing the tapestry and mounting it in the frame. Next, I proceeded to remove the old repairs and support the sky areas with a linen patch. The tapestry was then stitched into place across the warps as in weaving. I used neutral color for the stitching.

Before treatment it was not possible to make out the design of this work at close range, although it became very clear after treatment when the tapestry was hung. Thus I had achieved my aim. From this point on, I could see the way forward to future improvements.

After I left the Victoria and Albert Museum in 1959, I continued to introduce new members of the staff to these techniques. At my workroom in Ealing, they learned by working with me on tapestry conservation commissions from museums, the National Trust, and the Lord Chamberlain's office.

When Danielle Bosworth joined me in 1968, she took over the development and led the work on the Esther series then undertaken for the Victoria and Albert Museum. She introduced color indications into the couching and began to work on the problem of holes and their eye-catching effect on the viewer. This work is still developing. To restore a smooth surface to tapestries marred by holes, we eventually settled on stitching new warp yarns, dyed to match the old, onto the supporting patches and carrying background design features across the new warps. The intention is to lead the eye across the gap by using the most unobtrusive methods possible. These methods might vary from tapestry to tapestry.

We also realized the importance of full supporting linings for keeping fragile tapestries safe while they are hanging. The methods we devised to address this issue are described in our book, *Care and Preservation of Textiles* (Finch and Putnam 1985).

Even before the Textile Conservation Centre at Hampton Court Palace was established (Finch 1978), other textile conservators began to adopt our methods, presumably because they were suitable for their purpose, namely, fostering the appreciation of tapestries as works of art by attempting to give an illusion of the original. Paying careful attention to the balance and integrity of color and design in relation to the original date and techniques of weaving brought us closest to this purpose (Fig. 2 a,b).

Several members of the Textile Conservation Centre staff described the methods now in use at the center in a research report published in 1980 and revised in 1984. This report is available from the Textile Conservation Centre at Hampton Court Palace (Textile Conservation Centre 1984). Obviously, these methods do not remain static. The variety of differences in the tapestries themselves means that our work is always changing and that new problems continue to present themselves. We still need to know more about the long-term behavior of various types of dyestuffs in various surroundings; we need to know how to cope with these dyestuffs and how to cope with the damage inevitably caused by the drastic effects of cleaning and the elimination of pests.

Figure 2 a,b. Tapestry with Esther before Ahasueras. Before: Some dark outlines are missing, and the design is obscured by darning. After: The darning has been removed and the dark outlines replaced in their original space. The ribbon tie between the upper and lower sleeve is now discernible.

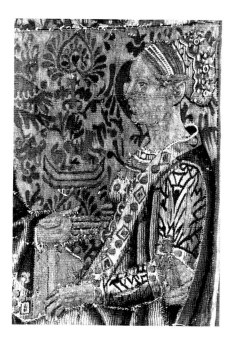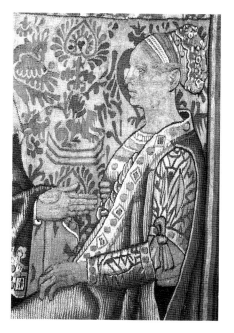

Conservation and Design of Tapestries

Documentation

Thorough documentation is necessary both before and after conservation. For every object they are commissioned to conserve, conservators need to research and record the technical aspects, including (in the case of tapestries) determining the fibers, dyestuffs, and techniques that went into the object's making. Apart from the value to the conservator, who needs to know and understand each object before commencing and recording its conservation, this work should also be valuable for future studies of similar objects (Finch 1985).

General Plea to Conservation Scientists

We must consider the health of textile conservators, who must be in the closest possible contact with the fabric of a tapestry in order to make the minute decisions that make or mar its design. Tapestry conservators have been adversely affected by the treatments listed below.

Insect-Proofing

Experience has shown that washing a tapestry previously treated with naphthalene releases odors that are so overpowering as to prevent conservators from doing further work on that tapestry (Eastaugh 1986).

Adhesive Treatments

Another bad experience occurred when we removed Vinamull from a Soho tapestry that had been glued to a nylon net.

In textile conservation, reversibility depends on size—and tapestries are *big* objects when it comes to the removal of an adhesive. In one case, six months of research could produce no alternative to using acetone in huge quantities. This was a frightening experience, even with the fire services standing by in case of emergency. The details are provided in two papers on tapestry conservation presented in Como (Finch 1980) and in Florence (Finch 1981).

Flame-Proofing

Two tapestries—each 15 meters by 7 meters—that were donated to the United Nations building in New York by the Swedish government had been flame-proofed with chemicals in which the pH had changed to 1. The acidity produced disastrous weakening of the tapestries and caused handling problems for the conservators. The effects of the acidity could not be reversed, and the tapestries are consequently so weak that they cannot serve as curtains, as originally planned (Finch 1969).

Final Comment

We hope that present and future scientific research into the problems encountered during treatment will help to prevent further disasters to our historic inheritance. Certainly it should be known that few of the early treatments were actually necessary, and all could have been avoided by better understanding of the initial problems posed by the tapestries in question.

References

Eastaugh, Nicholas
1986 Problems of Naphthalene Retention in Textile Artifacts. *Conservation News*.

Finch, Karen
1969 Flameproofing. *Studies in Conservation 14*. No. 3.
1978 The Establishment of a Textile Conservation Centre in Britain. Paper given at the ICOM Conservation Committee Conference in Zagreb.
1980 Changing Attitudes—New Developments—Full Circle. Paper given at the International Conference in Como, 1980. In *Conservation and Restoration of Textiles*. Edited by Francesco Pertegato. Milan: CISST.

1981 Problems of Tapestry Preservation. Paper given at the Tapestry Conference in Florence, 1981. In *Techniche di Conservazione Degli Arazzi.* Edited by Leo S. Olschi. Florence.

1985 Recording Evidence. Paper given at the Fifth International Restorer Seminar at Veszprem, Hungary. Edited by Istvan Eri. Budapest.

Finch, Karen and Greta Putnam

1985 *The Care and Preservation of Textiles.* London: Batsford.

Nielsen, Esther

1972 *Farvning Med Planter.* Copenhagen: Borgen.

Textile Conservation Centre

1984 *Tapestry Conservation Report.* London: Hampton Court Palace.

Biography

Karen Finch is founder of the Textile Conservation Centre at Hampton Court Palace, established in 1975. As Hon. Senior Lecturer at the Courtauld Institute of Art, she created the three-year postgraduate diploma course in textile conservation held at the Centre. Since her retirement in 1986, she has catalogued the Centre's reference collection. At present she is setting up a new course in the history of textile techniques for the Royal School of Needlework. A native of Denmark, she was awarded the Order of the British Empire for her work in conservation.

Conservation of a Fifteenth-Century Tapestry from Franconia

André Brutillot

Figure 1 (see Pl. 28). Gnadenstuhl, dovetailed joints on Saint Sebaldus' tunic.

The tapestry *Gnadenstuhl* (Holy Trinity), a funerary tapestry from the Oettingen-Wallerstein collection, is divided into three sections (Pl. 28). The Holy Trinity occupies the center, with God the Father holding Jesus on the cross and with the dove to the right of his head. Saint Sebaldus stands in the niche to the left with a sword and a model church; in the right-hand niche is the Archangel Michael, holding a sword in his left hand and a pair of scales in his right. The left side of the scales bears the weight of two demons. In spite of the millstones around their necks, the demons are nonetheless outweighed by the single soul occupying the right-hand side. The coats of arms featured here are those of the Nuremberg families Deichsler and Zeuner. Göbel writes in his book *Wandteppiche* 1933): "The donors could be Berthold Deichsler (died in 1419) and his second wife Agnes Zeunerin." He dates this tapestry around 1410.[1]

On closer inspection, we notice that the Archangel Michael is holding the sword in his left hand and that Christ's wound is on the right side of his breast and his head hangs to the right. Whether these observations are of any significance, from an art-historical or technical standpoint, for our knowledge of weaving in Nuremberg (Franconia) at the beginning of the fifteenth century is a matter that still remains to be investigated.

The tapestry is 1.33 meters long at the top and 1.32 meters long at the bottom. Its height is 0.745 meters. The warp thread is S-twist and consists of two filaments. The weft is made of polychrome wool, with linen for the white parts and metal threads made of gilded silver for Michael's collar, sleeves, and upper tunic border and for the dove's halo. The core of this metal thread is made of linen. There is also a touch of silk weft on the light-colored curls of Michael's hair. This gilded emphasis on the Archangel raises the question of whether he bore some particular significance to the donor or the weaver.

The upper selvage is still intact. The bottom of the tapestry has been cut, and probably the two sides as well, as evidenced by the fact that the warp threads barely extend beyond the weft threads. Furthermore, the pattern has been cut. The joins are often dovetailed in a way that is characteristic of Franconian tapestries (Fig. 1).

Figure 4, right. The back of the
tapestry showing a piece of
light blue material added to ex-
tend the length and width of
the lining.

Figure 5, far right. Folds
shown on Saint Sebaldus'
tunic.

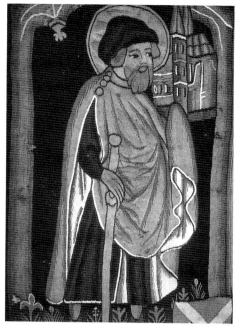

Result of Examination

Figure 2, top. Lining folded at
the bottom.

Figure 3, above. Lining folded
back.

The tapestry was hung in an unheated castle. The windows were not insulated against drafts until the mid-1960s. A lining of coarse, waxed linen material was too small for the tapestry. At the bottom and on the two sides, this lining was folded over the front of the tapestry (Fig. 2). At the top, a section of light blue material had been sewn on; it was framed by the lining and had been folded back (Fig. 3). The lining was too taut because it was too small; for this reason, it had been cut, and a piece of the material was attached to make it longer and wider (Fig. 4). Rings had been sewn onto this lining, and the tapestry was attached to the frame by a cord threaded through these rings.

The tapestry looked dusty. The windows of the castle did not close properly, and there is a cement factory situated nearby. A spectrum analysis on the tapestry indicated the presence of silicic acid, which could only have come from this factory. New, better-fitting windows have been installed in the castle in the meantime, and twenty years ago the factory itself was equipped with a filter plant. Temperature changes due to the lack of heat encouraged the growth of mildew on the tapestry. In addition, the usual street dirt was present.

There were also many creases and folds—for example, at the edges and on Michael's sleeve—caused at least in part by the fact that the lining was too tight. Some of the creases may also have resulted from the weaver's attempt to depict an arrangement of folds on Saint Sebaldus' tunic. The right and left sides of the tapestry are completely without folds, whereas in the area of the tunic there are suddenly a number of folds (Fig. 5).

Moreover, the warp does not run in a straight line. The tapestry also shows signs of contractions. It was so badly creased, especially at the edges, that the weak brown parts have disintegrated, leaving the white linen weft exposed. The warp is broken in only one place. On both sides, right and left, many wefts were hanging free. The lower edge was cut off; the upper edge was mainly intact except for several holes.

The tapestry has holes over its entire surface, particularly in the area of Saint Sebaldus (Figs. 6,7) and at the edges. Small rusty holes at the edges indicate that at one time the tapestry must have been nailed to a surface. The brown wool outlining the contours of the design is either broken or very fragile in many places. There seems to have been some damage in the blue areas on the back, although I did not find any

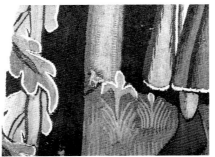

Figure 6, right. Detail showing damaged areas surrounding Saint Sebaldus.

Figure 7, below right. A hole in the tapestry to the left of Saint Sebaldus.

Figure 8, far right. Thick, waxed linen thread.

Figure 9, below, far right. Broken wefts.

larvae, eggs, or living insects present. Some of the broken brown contours had been mended with a thick, waxed linen thread (Fig. 8). The same method had been used to mend some small holes—in the blue tunic of God the Father, for example.

Some of the slits in the tapestry, especially at the top around the contours of the niches, had grown larger from the stress of hanging. The same was true in places where the weft is broken, for example, on Michael's white tunic (Fig. 9).

The Conservation

The tapestry was taken down, and the lining was detached. I left the dirt that had gathered in the folds of the lining. Then I left the object spread out flat on a table for a period of time to smooth it out. In the meantime, I asked restorers and chemists for their opinions on the best possible method of removing the dirt without damaging the tapestry. After many discussions, it appeared that the best way to start cleaning the tapestry would be to remove the dust thoroughly, collect it, and analyze it. The next steps would depend on the results of the dust analysis carried out by the chemists.

The following method was used to remove the dust: The tapestry was spread out on a frame covered with tulle and white paper was positioned under the frame. The section of tapestry to be cleaned was marked by a small window cut into a piece of cardboard and covered with tissue paper. All of the work was carried out with binocular microscopes. I removed the larger particles, most of which had settled in the slits, with a pair of tweezers. Then I removed the tinier bits of dirt, and those that were more deeply embedded, with a soft paintbrush and a vacuum cleaner, used very lightly. The nozzle of the vacuum cleaner was held at a distance of about 10 centimeters from the object and was covered with gauze, which also reduced its suction. First the dust was removed from the backside, then from the front. Each side required about eighty hours of work. Then the dust from the vacuum-cleaner bag was gathered together with the dust that had fallen onto the white paper and sent out for analysis.[2] The result showed that there was no dirt present that would destroy the fibers by chemical reaction. The only greater risk was a mechanical one, namely, that the fibers might inadvertently get ruptured in the course of moving the object. After a great deal of dirt had been removed, particles of dust embedded in the fibers could still be seen under the binocular microscope. The question remained whether or not to wash the tapestry.

My own opinion—and that of my colleagues from the textile conservation studio in the Bayerisches Nationalmuseum—was that the tapestry was too fragile to risk wet cleaning. Too many wefts, especially the brown ones, were much too fragile, and many of these fibers could be washed away, even if I washed the tapestry with the utmost care. Furthermore, there was the danger that washing would put too much stress on the linen warp threads, thereby threatening the stability of the entire tapestry. Moreover, the old linen would have stretched and would not have regained its previous form. Dry cleaning was out of the question because of the risks posed by the mechanical aspect of the treatment (that is, the movement in the machine) and because the use of perchlorethylene could well be problematic. Other methods, such as cleaning with a mixture of water and alcohol, ran the risk, in my opinion, of lodging the remaining dirt even more firmly in the fibers, which would be partially swollen by this cleaning process. The same argument applied to the possibility of washing. The dirt could be thoroughly removed only by a "rough" washing, and, as mentioned, this would have been too much for the tapestry in its fragile condition. Before making this extremely difficult decision (whether or not to wash), I consulted other textile restorers in Bavaria, especially in the workshops of Nuremberg and Bamberg, and most of them were of the opinion that washing would be too dangerous.

A further problem remained. As previously mentioned, there was mildew on the tapestry. The efflorescence had disappeared when the dust was removed, but the spores were still present. Gassing with ethylenoxide ran the risk of speeding the tapestry's deterioration; gassing with hydrocyanic acid could cause the metal threads to blacken. The suggestion that the tapestry be treated with 70-percent alcohol was also rejected because I considered the process to be too dangerous for the fibers (alcohol draws the grease out of the wool) and not fully effective in eliminating the spores.

I read some literature on this subject and continued to ask for advice among my colleagues in Berlin and Paris; I also consulted Dr. Liliane Masschelein-Kleiner in Brussels. All of this research confirmed my opinion that a constant relative air humidity of 50 percent would prevent the reemergence of mildew efflorescence. Treatment for mildew is dangerous for the tapestry in any case; furthermore, it does not prevent the appearance of fresh mildew in a room where the relative air humidity is constantly changing. For these reasons I asked the owner of the tapestry to provide for a constant relative air humidity in the exhibition rooms. These rooms contain other Franconian tapestries from the same period, and they too will benefit from a constant temperature and relative air humidity.

To consolidate the fragile parts, I used silk threads of a finer quality than the texture of hair and doubled them. The sewing needles, straight or round, were also extremely fine. The threads were dyed to the appropriate shades with dyes manufactured by Ciba-Geigy. As a first step, the edges were fastened. Then, bit by bit, untreated woolen fabric was positioned under the fragile parts. In this case wool seemed preferable to linen, since the main material in the tapestry was wool.

The woolen material is, of course, heavier than linen, but the weight factor did not seem of primary importance because the tapestry is not very large, and it does not have to hang vertically. The woolen material was dyed in the same way as the silk. Then the pieces of material were sewn with silk threads onto the fragile places of the tapestry, which was spread out on a table. In the places that were not quite so badly damaged I merely tacked the supporting material. In the other places, where necessary, I used tacking and couching. If the part was extremely fragile and the couching stitches were close together, then I did not tack (Fig. 10).

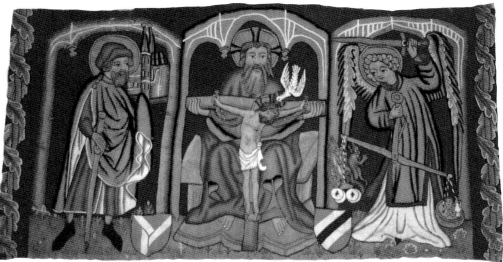

Figure 10, above. Couching stitches.

Figure 11, right. After conservation.

Creased areas had to be treated differently because it was impossible to lay the supporting material out flat. Working on a table with removable parts, I had to fit the support into the creases with my fingers, especially in the area of Saint Sebaldus' tunic and also around the edges.

Michael's face was fastened only with tacking stitches, since couching stitches would have given the appearance of scars. The slits occurring in the architecture above the saints were also supported so as to prevent them from expanding any further. In addition, the tapestry was lined with a light but firm linen cambric cloth, attached by a pattern of tacking stitches.

A strip of Velcro was attached to the top edge of the tapestry, which was mounted on a flat supporting board covered with baize and linen (Fig. 11). This mounting does not hang vertically against the wall but is tilted at an angle. The entire mounting will eventually be covered completely with glass or plexiglass to prevent further damage.

The conservation of the tapestry took, all in all, about one thousand hours.

Acknowledgments

The translation of the text was by Heather Moers.

Notes

1. See also Kurth, 1926:1 774–775; 3:258, for a photograph and description of the tapestry.

2. Analysis by the Doerner-Institut, Dr. Burmester.

References

Göbel, Heinrich

1933 *Wandteppiche: Die germanischen und slawischen Länder*. Berlin: Verlag Klinkhardt & Biermann.

Kurth, Betty

1926 *Die deutschen Bildteppiche des Mittelalters*. Volumes 1 and 3. Vienna: Verlag Anton Schroll & Co.

Biography

André Brutillot is a textile conservator in private practice and on staff at the Bayerisches Nationalmuseum in Munich. Originally from France, he received his training in textile conservation in Munich.

The Tapestries of the Sala dei Duecento in the Palazzo Vecchio

Loretta Dolcini

When Dr. Masschelein-Kleiner invited me to take part in this seminar, I immediately thought of discussing the tapestries in the Palazzo Vecchio because most colleagues in the field are familiar with their problems and take an interest in their welfare.

The series of twenty tapestries, conceived originally as decoration for the Sala dei Duecento, was woven between 1545 and 1553 for Cosimo I de'Medici by two Flemish weavers, Niccolò Karcher and Giovanni Rost. The cartoons were designed by the main Mannerist artists of the time: Angolo di Cosimo Tori, called Bronzino (1503–1572); Jacopo Carruci, called Pontormo (1494–1557); and Francesco de'Rossi, called Salviati (1510–1563). The tapestries depict the biblical stories of Joseph and his brothers.

At first the series was hung only on special occasions, and not exclusively in the hall for which it was intended but also outside. Later on the tapestries were exhibited less and less frequently; during the eighteenth century they were stored in the cloakroom for an extended period. In 1872, ten tapestries were hung in the Sala dei Duecento, where the town council convened. These tapestries remained there more than a hundred years until 1983, when they were all taken down. In 1887, the other ten tapestries in the series were sent to Rome to decorate the Quirinal, where they still remain.

In the description of the restoration treatment that follows, one tapestry will serve as an example for all, namely, *The Dream of the Sheaves of Corn* (Fig. 1), which was the first to undergo conservation. It is one of the smallest of the series—6 meters high by 3 meters wide. Before restoration began in 1985, we organized an exhibition illustrating the results of our preliminary research on the history of these tapestries, their weaving technique, and their original materials. We subsequently published the results (*Gli arazzi della Sala dei Duecento* 1985).

For the present purposes, I would like to focus on what has actually been done since 1985. Our work team consists of full-time conservators Laura Maatta Niccolai, Carla Molin Pradel, and Costanza Perrone Da Zara; one expert specializing in dyeing; two chemists; a project director (myself); a technical supervisor; and several part-time assistants. Labor costs amounted to seventy million lire each year; a bank underwrites this entire sum. Although the exact figures cannot be accurately calculated, I estimate that public institutions, the Commune, and the State (which owns

Figure 1, above. The first tapestry to receive treatment, The Dream of the Sheaves of Corn.

Figure 2, above right. Our new, fully equipped laboratory.

Preliminary Documentation

the tapestries) contribute approximately fifty million lire to our budget. In the near future our organizational costs will be greatly reduced thanks to our new fully equipped laboratory (Fig. 2), which is splendidly located right at the foot of the tower of the Palazzo Vecchio. The total cost for the restoration of ten tapestries, calculated in 1985, will not be less than one billion lire, or about $750,000.

As far as the technical aspects of the treatment are concerned, the remarks that follow address three topics: first, preliminary documentation; then, briefly, the washing process;[1] and, finally, actual conservation/restoration.

The purpose of this restoration is to allow these tapestries to be hung once again; at present they are too fragile. Our aim is to consolidate them structurally and also to conserve them so that there will be no need for further restoration in the near future.

In planning a restoration program for a tapestry, we usually face the problem of developing an accurate assessment of its actual condition. In fact, while it is easy to evaluate specific alterations in specific areas of the tapestry, it is much more difficult to draw up an overall assessment that will help us to decide on the optimum methods and theory to be followed. Drawing on this overall picture, we must establish a technical procedure that meets our theoretical requirements as to the object's basic conservation needs. This is the basis for our approach to restoration, not just for textiles but for other works of art as well.

We begin developing our overall assessment of the problem, by drawing a graphic reproduction of the tapestry at a scale of 1:6 (Pl. 29). On our scale drawing we record all kinds of information, such as the position of the old linings (in the case at hand, the linings were the originals) or the presence of earlier repairs consisting of clumsily darned patches. As indicated on the drawing, most of the ten tapestries in the Palazzo Vecchio have never been restored; only three of them have ever been treated. Unfortunately, these three were badly damaged.

The drawing also documents the tapestry's current state of conservation and the presence of different kinds of damage and deterioration, as indicated by various

symbols. We distinguished four levels of deterioration: (1) slight wear, (2) more severe wear, (3) total loss of wefts, and (4) total loss of wefts and warps. In the case of particularly badly damaged areas, we indicated the color of that part of the tapestry on the drawing. This method revealed that damage caused by dyeing techniques involved only a few colors. We were thus able to assess this damage accurately, noticing that, as usual, black- and brown-dyed yarns are especially subject to damage, as well as a certain color of beige on silk used for women's flesh tones and a particular shade of pinkish red.

In order to understand the type and extent of damage, we had to classify it according to the different fibers used in weaving the tapestry. We therefore drew up a graphic design in which the color blue indicates silk, yellow stands for wool, and gray for metal yarn. We then superimposed the overlay showing the damaged areas on the fiber diagram; this gave us a picture of the relationship between type of damage, fiber, and color (Pl. 30, Fig. 3). By showing us which fibers tend to deteriorate most rapidly, this picture also helped us to evaluate the future risks to the tapestry: It provided a diagram of the exact quantities of each fiber used for the weft. This last analysis will also be used to compare the tapestries in terms of their weaving; differences among them inevitably resulted from the fact that the series was produced in two different workshops.

The diagram shows the tapestry divided into sections indicating the quantities of wool, silk, or metal yarn present in that area. By totaling the results of all of the sections we get the overall average. In this way we established that our sample tapestry is made of 55-percent silk, 36-percent wool, and 9-percent metal yarn. Having the means to analyze and synthesize technical information in such great detail has proved extremely useful and has made it easier for us to choose our technical procedure.

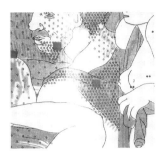

Figure 3. The drawing showing the relationships between types of damage, fiber, and color.

Washing

Following the preliminary studies, we proceeded to wash the first two tapestries. The dirt we found on the tapestries was the kind produced by air pollution, accumulated over a long period of exposure. A wide variety of soil particles had penetrated the porous fibers, where they were lodged in an oily film. In other words, the dirt called for a liquid detergent solution. In choosing the type of water for this procedure, we had to consider the huge quantities that would be necessary (about 7,000 liters) and the need to protect the fibers and the dyes. In consultation with the chemists, we decided to use a kind of water similar to common mineral waters—Florence city tap water partially softened and treated to eliminate chlorine.

In accordance with the principles guiding this project and the tradition of our laboratory, we chose to use only natural detergents. We tested the following agents:

- Watery solution of saponin, a refined natural product in powder form, produced by Carlo Erba
- Neutral detergent produced by Nuova Pieffe in Vicenza
- Tween 20, produced by Merck, usually used on metals

For each of these surface-active agents, we assessed the following factors:

- pH
- Electrochemical conductivity at various levels of concentration
- Reactivity to metals (silver)

We chose the Carlo Erba saponin detergent because this product caused no further oxidation in the experiments testing reactivity to silver. We decided to use it in a concentration of around 0.2 percent. We tested a wide range of samples for color

stability and charted the results obtained for the dominant tonalities: red, pink orange, yellow, blue, brown/black. These last shades created the most problems not only because of their instability but also because of the pulverization of the fibers. It was clearly essential to limit the period of the tapestry's immersion in the solution to the absolute minimum and to expedite its drying under natural conditions.

Before washing, a type of heat-welded soft netting was attached to the back of the tapestry to support and protect the more deteriorated areas. In some particularly badly damaged sections, we attached a lighter kind of netting, nylon tulle, on the front. These temporary supports were sewn to the tapestry with a very fine undyed silk thread.

The washing, which took approximately twelve hours in all, proceeded according to the following schedule:

7:30 a.m	The tapestry was placed front side up on a steel grid raised about 8 centimeters above the surface of the washtub. We chose to wash only the front of the tapestry because we wanted to avoid rolling it up while it was wet.
8:00 a.m.	The fabric was sprayed uniformly by sprinklers on a mobile scaffolding. The detergent solution was applied evenly with atomizers before the tapestry was submerged.
9:00 a.m.	The whole surface of the tapestry was sponged.
10:00 a.m.	The tub was drained.
11:30 a.m.	The tub was filled again for the second washing.
12:30 p.m.	Sponging was repeated, and the metal parts were very lightly brushed.
2:00 p.m.	The tub was drained again.
3:00 p.m.	Rinsing followed. The sprinklers were ferried back and forth across the tapestry, saturating it once again with rinse water.
4:00 p.m.	Rinsing was completed; demineralized water (120 liters) was poured in by hand.

At the conclusion of this last step, excess water was soaked up immediately with large pieces of blotting paper. The tapestry was then returned to the steel grid used for washing and was placed on a table to dry. Left under natural conditions in a well-ventilated room and turned once the following morning, the tapestry dried in approximately 24 hours.

During the washing operation, the following chemical and physical characteristics of the water were recorded:

- Electrochemical conductivity
- pH
- Hardness
- Chlorine concentration
- Nitrate concentration
- Sulfate concentration

These controls were carried out at the following stages in the process:

1. Immediately after the tapestry had been submerged
2. After the detergent had been added (about an hour later)
3. At the end of the washing process
4. After the first rinsing
5. After the second rinsing

The electrochemical conductivity increased slightly when the tapestry was submerged; it remained constant, as we had predicted, when the detergent was added (indicating that the water itself has a strong cleansing effect); and decreased considerably during the rinsing, falling back to the original level. The hardness of the water remained more or less constant throughout. The salt concentrations increased progressively—the chlorides and the nitrates in particular—before returning to levels close to the ones recorded at the outset. This indicates that washing removed the salts from the fabric effectively and that rinsing eliminated them.

We can conclude that the detergent solution had a direct effect on the fibers because it removed the dirt from the spaces between them, making the fabric softer and more flexible. Even the slight structural deformations in the fabric—particularly in the warps in areas where the wefts were missing—were partially improved in the process. Washing also noticeably improved the tapestry's aesthetic values: the fibers became brighter, the colors grew more intense, and the metal yarns regained their shine.

The foam present during the washing was unstable and easy to eliminate. Both the tulle and the netting sewn onto the back and the front worked very well as protection for the damaged areas, but they also tended to retain the dirt. We therefore concluded that such protection should be used only in cases of absolute necessity.

The steel grid on which we spread out the tapestry somewhat inhibited the elimination of dirt from the back of the fabric. We therefore concluded that it would be better in the future to wash the tapestry on both sides, starting from the back. The instability of some color dyes turned out to be the worst aspect of the operation. The water became slightly colored near the red areas of the tapestry. Attention must be paid during the intervals between one submersion and the next while the tapestry is out of the water. Although we prefer a simple detergent solution as a general rule, a certain amount of acetic acid can be added to the water during the final rinsing (when the tapestry is submerged very briefly) to lend stability to the less stable dyes.

Conservation/ Restoration Treatment

The conservation/restoration treatment of these tapestries is still in progress at the time of this writing. Before beginning treatment, we outlined the general condition of the tapestries as follows:

- The pattern is well preserved as a whole and in details.
- Most of the colors are well preserved, as we learned from washing the tapestry.
- The wool is well preserved, both in the warp and in the weft.
- The silk is damaged, particularly in certain areas.
- Many slits are open or weak.

Certain areas of the silk weft need to be thoroughly consolidated, and the tapestry as a whole needs greater structural stability. The structural weakening of the entire series can be blamed only in part on the deterioration of the fibers; it is very often a result of the deterioration of the slit areas, which occurs within the pattern in such a way as to provide a major part of the support of the whole tapestry. We decided to start by repairing the slits and the less damaged parts so that the tapestry would not require a total supporting structure. Our intention is to reduce the number of local supports required to a minimum. This phase of the work takes place on a kind of table that allows the conservator to open up the tapestry surface to the exact area he or she wishes to work on. At this point, the tapestry is still supported by the fabrics used as protection during the washing. These will be removed as we consolidate the single areas of the tapestry. To sew the slits, we use a cotton thread that we have dyed in the six basic colors of the tapestry. All yarns are dyed in our laboratory

after thorough testing of different dyestuffs and dyeing techniques to guarantee optimum stability.

In some places a few silk wefts are missing near the slits, and, because these areas are important to the overall support, we reweave the weft in order to lend strength. For these small reweaving operations, we use a silk thread dyed in a color that has morphological qualities similar to those of the original fiber. We work these small sections painstakingly, knowing that they serve both aesthetic and functional purposes.

For very small damaged areas located next to well-preserved areas we carry out an overall reweaving job if the damage is restricted to a single color and if there is no doubt about the pattern (Pls. 31,32). I do not think overall reweaving poses a problem as long as it is restricted to this kind of damage. At the same time, we also treat some damaged weft areas with wide wefts of wool and silk in order to reinforce the original texture and to soften the color contrast between undamaged areas and those where the warps are uncovered (Pls. 33,34).

I would like to stress the importance of this part of the work process for our tapestries. They do not have large, badly damaged sections; their problem is more a matter of gradual deterioration. This patient remediation of small problems is aimed at the long-term upkeep and preservation of the tapestries. This approach requires the attention of careful and expert conservators, as well as a great deal of time for the preparation of the conservation yarns and for the actual work. I am confident, however, that all of this outlay of human and financial resources will be rewarded.

More severely damaged sections of the tapestry—areas where the high percentage of missing wefts makes it impossible to connect the lines of the pattern or to reweave—will be treated with a local support. We have indicated these areas on a diagram so that we can see how the supports will be distributed and assess their overall effect before we attach them.

Since the badly damaged areas vary in size and extent of deterioration, we decided to use three different linen fabrics (of different weights) in tabby weave for the supports. We also considered the possibility of using cotton, but the results of the application tests carried out by the conservators were disappointing. The fabrics were tested for weight, density, resistance to traction, and stretching. On the basis of these tests, we chose the best-quality linen available.

To attach the support to the tapestry, we are thinking of using a cotton yarn, but, as we have not yet performed this operation, we are still considering the possibility of using a silk thread. The borders of the supports will be sewn to the well-preserved areas of the tapestry, and single warps will be attached to the underlying support on a loom. Our consolidation process provides the tapestries with some essential supports at the back, and the many instances of structural repairs strengthen the best-preserved areas of the tapestry.

Once the conservation treatment is completed, the tapestries will be lined, although we have not yet decided on the technical details of the operation. We plan to exhibit three restored tapestries in 1990.

Notes

1. For a very detailed description of the washing procedure, please see our bulletin, *OPD Restauro* 2 (October 1987).

References

1985 *Gli arazzi della Sala dei Duecento.* Exhibition catalogue. Florence.

Biography

Loretta Dolcini joined the Opificio delle Pietre Dure in 1978. Until 1984 she directed the organization's three-year school of restoration while also heading their restoration laboratories for textiles, gold, and bronzes. Since 1977 she has also served on the State Ministry of Cultural Affairs.

Gluttony and *Avarice*:
Two Different Approaches

R. Bruce Hutchison

Object: Tapestry, *Gluttony*, Flemish (Brussels), designed by Pieter Coecke van
 Aelst (1502–1550), probably circa 1540, probably woven 1560–1575
Materials: Warps, wool; wefts, dyed wool, silk, and silver- gilt thread
Dimensions: 3.89 meters x 6.78 meters (12'9" x 22'3")
Provenance: Gift of Mrs. Frederick R. Coudert, Jr., in memory of Mr. and Mrs. Hugh
 A. Murray, 1957 (57.62); The Metropolitan Museum of Art, New York

Object: Tapestry, *Avarice*, Flemish (Brussels), designed by Pieter Coecke van
 Aelst (1502–1550), probably woven by Willem de Pannemaker, circa
 1535–1550
Materials: Warps, wool; wefts, dyed wool, silk, and silver-gilt thread
Dimensions: 4.75 meters x 7.39 meters (15'1" x 24")
Provenance: Purchased for the Pierpont Morgan Library, East Room, in 1906 from
 the F.B. Palmer collection, London; Pierpont Morgan Library, New York

These two tapestries, each representing one of the seven deadly sins, came to the Textile Conservation Laboratory of the Cathedral Church of St. John the Divine, New York, in July 1984 and December 1984, respectively, in markedly different conditions. Of the two, *Gluttony* presented the sorts of representative problems faced by tapestry conservators. In its existing condition, *Gluttony* came as close as possible to what one might call an archetype, given that it also had unique aspects. For this reason, *Gluttony* will serve to demonstrate a general approach to tapestry conservation. The extensive deterioration of *Avarice*, by striking contrast, required a far more drastic approach. *Avarice*, therefore, will serve to demonstrate an exceptional treatment. A comparison of these treatments will elucidate two different approaches to tapestry conservation. Comparing very similar tapestries side by side serves to underscore the points of departure in choosing treatment.

Each tapestry of the Seven Deadly Sins series depicts a deadly sin, personified as a woman with wings, riding a cart drawn by fantastic beasts emerging from hell on the left. The cart is surrounded by figures whose lives have epitomized the sin being portrayed. The opposing virtue flies over the scene.

Gluttony, which belongs to The Metropolitan Museum of Art, is thoroughly described and discussed by Edith Standen in her book *European Post-Medieval Tapestries and Related Hangings in The Metropolitan Museum of Art* (1985:110; entry 13). *Avarice*, from the Pierpont Morgan Library, New York, is also mentioned by Miss Standen. Dr. Rotraud Bauer refers to both of these tapestries in her book *Tapisserieen der Renaissance* (1981:55). A complete set of seven tapestries is in the Kunsthistoriches Museum in Vienna. Two incomplete sets—one set of four and another set of six tapestries—are in Spain. The two tapestries that came to our laboratory are evidence of yet a fourth and fifth edition of the series.

The top and bottom borders of *Gluttony* appear to be replacements, as evidenced by the quality of the wool and weaving techniques. Another 7.5 centimeters to 15.4 centimeters (3–6 inches) above the bottom border has also been rewoven. Along the inside edge of the border on the upper right-hand side there is a 144-centimeter (45-inch) tuck in the tapestry. Although the tapestry is in generally stable condition, it has suffered large losses of silk in various areas and some losses of dark brown wool.

Avarice was purchased by Pierpont Morgan in about 1906. Since the time of its acquisition, it has hung in the East Room of the library, over the fireplace. A large decorative marble frontispiece to the mantle extends in front of the lower portion of the tapestry. The sides of the tapestry have been turned back to fit the space between bookcases. The library was originally heated by coal, and the tapestry was also exposed to other environmental pollutants characteristic of large cities. These conditions have improved in the meantime, with environmental controls and better lighting installed throughout the library. A notation in the records indicates that at some time prior to 1969 the tapestry was treated flat on the floor of the library. *Gluttony* used to be vacuum-cleaned periodically; this procedure was eventually discontinued because of the fragility of the piece.

Prior to beginning our treatment, all backing, rings, and any unrelated fabric patches were removed from both tapestries as a matter of course. The tapestries were vacuum-cleaned through nylon netting, front and back, to remove surface dirt. To test for colorfastness, we saturated yarns taken from the backs of tapestries with the wash solutions and allowed them to dry between swatches of washed cotton fabric. Particular attention was paid to testing areas of previous repairs. Weak areas of each tapestry were sandwiched between layers of nylon netting.

Throughout the United States, Orvus WA paste, a neutral (7.8 pH) synthetic anionic detergent (sodium lauryl sulfate) made by Procter & Gamble, is used in cleaning most historic textiles. *Gluttony* was washed with the customary Orvus solution (1% w/v). *Avarice* required a more potent cleansing because of a heavy accumulation of soot and oil. The latter was initially washed with a detergent solution containing Igepal CA 630, a nonionic detergent similar to Lissapol. For this type of detergent, sodium carboxymethyl cellulose (SCMC) is often used in conjunction with Igepal as an antiredeposition agent. However, because of the viscosity of SCMC, this course of action was rejected. Instead, the tapestry was subjected to two separate washing solutions: the first with nonionic Igepal (25 ml to 9 L deionized water), chosen for its oily-type soil-releasing capability; the second with anionic Orvus (1% w/v), selected for its soil-suspending properties. We expected that this procedure would cleanse the tapestry just as if we had combined a nonionic detergent with an antiredeposition agent. (We do now combine the two detergents together, particularly for cleaning city-soot-type grime from textiles.)

Our laboratory wash table is constructed of wood; it measures 5.03 meters x 6.10 meters x 12.5 centimeters (16' x 20' x 5") . The table is lined with 6-mil polyethylene sheeting. Extending over the surface of the table are stainless steel wash screens,

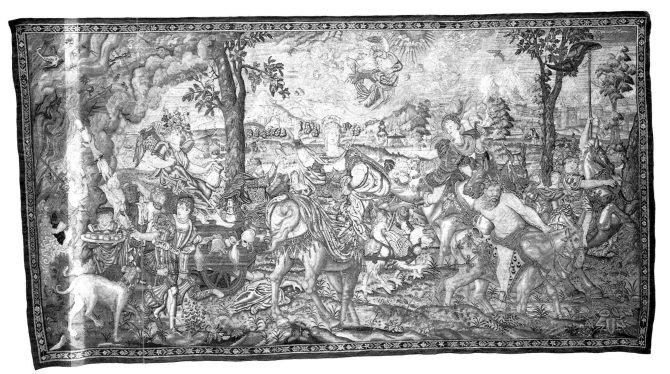

Figure 1. Gluttony, *overall view, shown before treatment.*

each measuring 1.18 meters x 1.48 meters (3'10" x 4'10"), perforated by 1-centimeter (3/8-inch) holes. The screens are elevated 4.5 centimeters (2 inches) above the table surface on feet. A free-rolling bridge spans the width, allowing the wash team to be ferried back and forth above the surface of the tapestry.

Since the length of the tapestries exceeded the length of the table, one end of each had to remain rolled on a tube during the washing. Each tapestry was placed on the wash screens—dirtiest side down—and thoroughly saturated with deionized water as quickly as possible, including the section that remained rolled. Spraying continued until the water flowed easily through the tapestry. Then the tapestry was sponged by hand with the wash solutions, rinsed, and resudsed. After another rinsing, the tapestry was repositioned to sponge the rolled-up portion. The tapestry was rolled back up again while the wash table was rinsed as thoroughly as possible, after which the tapestry was returned to the table and unrolled face up for a series of rinses that continued until there was no visual evidence of detergent. The position of the tapestry had to be adjusted during this process to make sure that the ends were rinsed equally. Next, the tapestry was rolled in terry towels to remove excess water. Finally, it was laid out on homasote[1] boards that are covered with contact paper and allowed to dry.

Gluttony (Fig. 1) presented the usual assortment of mending problems—small, well-defined areas of wool and silk loss, open slits, large areas of silk loss, and some old repairs, which raised the following questions: Is the old repair causing physical stress to the tapestry? If so, how much? Does it interfere with the tapestry's visual harmony? How much original material will be lost in removing old mends? Can the old repairs be replaced with something better? Reweaving well-defined losses of silk or dark brown wool has proven appropriate in many cases. For wool repairs, commercially dyed wool yarns are usually chosen. For replacing silk, DMC cotton embroidery thread is preferred because of its longer life expectancy and because it has less sheen than modern silk thread. It is preferable to incorporate the repair by stitching into the construction of the tapestry if possible, rather than attaching many little patches to the back. This repair is best achieved using either wool or cotton thread in an open tabby mend, spaced about 0.4 centimeters (1/8 inch) apart and extending well into

Figure 2. Gluttony, *detail of Silenus' beard showing tabby mend to support patch.*

the undamaged surrounding area. This type of repair adapts more sympathetically to environmental changes than those repairs that have yet a third component of a fabric patch. On the other hand, large areas of loss—30.5 centimeters (12 inch) square or larger—where warps are well exposed are best treated by adding a support patch. A suitable fabric for patching is washed twill cotton, which may be commercially dyed to match the repair area. If warps are missing or broken, they can be superimposed on the fabric. An open tabby mend sewn with two strands of DMC embroidery cotton thread attaches the patch support to the tapestry (Fig. 2). The edges of the patch are secured with a zigzag stitch into the undamaged surrounding area of the tapestry.

Strap supports are designed to secure the tapestry without binding it; they allow for a certain amount of fluctuation in the environment. Considering the age and condition of most tapestries, a strap support is usually warranted. In the case of *Gluttony*, nineteen 7.5-centimeter (3-inch) tapes made of washed cotton in a herring-bone twill were positioned approximately 30.5 centimeters (12 inches) apart across the back of the tapestry. These tapes were allowed to hang freely from the back. While two people applied a slight amount of opposing tension across the face of the tapestry, the tapes were pinned in place, starting at the top and working out from the center tape and continuing down the back of the tapestry in that order. The tapes were then attached with heavy-duty cotton thread in a continuous running stitch down each side of the tape. The stitching passed over one warp of the tapestry approximately every 5 centimeters (2 inches). At times it was necessary to elongate a stitch to avoid particular areas of weak wefts and fragile silk. Additional thread was added when needed, secured by a knot that floated between stitches.

A dust cover is an essential accessory to strap supports. Previously washed cotton sateen served this purpose. The fabric was stitched together by machine and attached at the top with a whip stitch and down each side with a continuous running stitch. A 30.5-centimeter (12-inch) band of the same cotton fabric was attached along the bottom edge of the tapestry to protect the work against updrafts of dust. Because of the size and weight of *Gluttony*, a 7.5-centimeter (3-inch) band of nylon seat belt

Tapestries: Two Different Approaches

webbing instead of the usual Velcro band was attached with heavy-duty button and carpet thread along the top of the tapestry. Two rows of staggered stitches, alternately knotted, were sewn—one along the bottom edge of the webbing, the other approximately 1.22 centimeters (1/2-inch) from the top edge, allowing for a 1.22 centimeter (1/2-inch) heading band to be nailed to a batten. Because of the size of the tapestry, a second band of nylon webbing and Velcro was attached only to the straps, directly through the dust cover across the middle of the tapestry. Moreover, in order to help transfer some of the tapestry weight to the webbing at the top, the straps were fastened to the bottom of the nylon webbing with whip stitches sewn through the dust cover.

Close inspection of *Avarice* (Pl. 35) revealed that at least three-quarters of the tapestry would need to be mended with patches. To avoid this undesirable effect, the decision was made to employ a full supporting backing instead.

In the United States it is unusual to encounter tapestries needing full support backings. However, when the condition is so fragile as to warrant such an approach, the fabric chosen should indeed support the textile. A commercially dyed washed cotton twill, medium weight, 140 centimeters (55 inches) wide, was prepared as the support fabric for *Avarice*. The first panel was aligned with the warps of the yardage at right angles to the tapestry. The panel was pinned in place as flat as possible following the contours of the tapestry. An overall grid of vertical running stitches was sewn with button and carpet thread in rows 30.5 centimeters (12 inches) long and spaced at a distance of 30.5 centimeters between rows to secure the tapestry to each panel. All repairs were stitched through the backing using two strands of DMC embroidery cotton, again in an open-spaced tabby mend. This mending proceeded panel by panel (Pls. 36,37). A new panel was attached to the tapestry only when repairs on the previous panel were finished. Upon completion, the tapestry was removed from the tensioner/work frame and then suspended to hang out. The long tails of the grid sewing threads were tied together to form one long, continuous thread. In order to relieve the tension of the selvage edges on the support panels, they were snipped every 30.5 centimeters (12 inches) and the panels were loosely laced together with a zigzag stitch. A lightweight cotton print cloth was washed and pieced together as backing for the support fabric and to protect the mending threads. The excess support fabric that extended beyond the borders of the tapestry was turned back double and sewn to the print cloth. A 5-centimeter (2-inch) Velcro band, machine-stitched on nylon seat-belt webbing for reinforcement, was sewn by hand along the top of the tapestry. Also, 3.76 centimeter (1 1/2-inch) D-rings were sewn along the top of the Velcro band, spaced about 30.5 centimeters (12 inches) apart. A corresponding Velcro band was attached to a batten mounted on the wall over the fireplace. Nails corresponding to the D-rings were also secured along the top edge of the batten. The D-rings were hooked onto the nails as a precaution in case the Velcro should come loose.

Two issues raised by this discussion deserve additional remarks. The first regards the use of cotton as opposed to linen for the support backing of textiles. Obviously, it would seem desirable to use like fabrics as backing for textiles—i.e., silk for silk, linen for linen, etc.—because they would respond in kind to environmental changes; however, some fabrics do not provide the needed supportive qualities. For a historic tapestry of wool or silk, certainly neither of these fabrics would be practical as material for support backings. For large historic textiles, we often use cotton instead of linen for support backings because the differences in their relative hydroscopic properties are virtually inconsequential in the United States, where most art objects are destined for environments that are at least moderately controlled. Even in poorly controlled environments, cotton does not react as quickly as other fabrics to seasonal

fluctuations, which can be significant in the United States. Good-quality cotton is readily available in the United States and is therefore the practical choice.

Another area for further comment concerns the use of strap supports. These have been used for a number of years in the United States, first in the form of fabric widths 18 centimeters to 25.2 centimeters (7–10 inches) wide, positioned 18 centimers to 25.2 centimeters (7–10 inches) apart. At the present time, 8-centimeter (3-inch) cotton herringbone twill tape is preferred, fastened 30.5 centimeters to 38 centimeters (12–15 inches) apart. There is still some debate about returning to fabric widths and to regular spacing of support stitching.

Over the last fifteen years I have observed tapestries with straps, some of which have been on continuous display. I have seen no evidence of the so-called swag effect that is sometimes raised as an objection to the use of straps. Another objection is that they form bands of shadow on the face of the tapestry. This same case can be made against patches, namely, that they create shade distortions, especially by trapping environmental dust. The use of a dust cover in conjunction with support straps has overcome this argument against their application. The straps also offer the advantage of easy access to the back of the tapestry. A further advantage is that, in the event of moisture, a pocket of air between the dust cover and the tapestry protects the object from direct contact with dampness.

Obviously there is no single, clear-cut approach to tapestry conservation. Each tapestry comes with its own unique inherent problems along with problems caused by the local or regional factors to which it has been exposed. In developing a uniquely suitable approach to each tapestry, we as conservators are, in turn, dependent on the materials available to accomplish our best work.

Notes

1. Homosote is a generic name for a pulp paper board product used in the United States.

References

Bauer, Rotraud

1981 *Tapisserieen der Renaissance nach Entwurfen von Pieter Coecke van Aelst.* Exhibition Catalogue. Burgenland: Schloss Halbtur.

Standen, Edith Appleton

1985 *European Post-Medieval Tapestries and Related Hangings in The Metropolitan Museum of Art.* Vol. 1. New York: The Metropolitan Museum of Art.

Biography

R. Bruce Hutchison is chief conservator, Textile Conservation Laboratory at the Cathedral Church of St. John the Divine, New York, a facility specializing in large-scale textiles. He received his education at San Francisco State University and further training at institutions in Denmark, Sweden, and England under a grant from the National Endowment for the Arts.

Two Case Histories: A Seventeenth-Century Antwerp Tapestry and an Eighteenth-Century English Soho Tapestry

Ksynia Marko

A major portion of the work of the Textile Conservation Studio concentrates on the treatment of tapestries. At least three tapestries are always being treated at one time. As soon as one is completed, work on another has already started.

Most of the tapestries belong to historic house owners or to the National Trust. They are on open display in houses visited by thousands of people every year. The care and conservation of tapestries has been a major problem for the National Trust for many years. In the past, many pieces were sent abroad for restoration. This often meant that the Trust had little control over treatment. With the greater appreciation of conservation today, tapestries are no longer sent abroad. In the past, some work was also carried out in the restoration workshops of tapestry and carpet dealers in London. It has become our task to rectify the mistakes of some of this past treatment.

This paper addresses only two of the many problems faced by textile conservators. The first is that of rectifying damage caused by adhesives; the second concerns the sewing and support of brittle silk weft.

A Seventeenth-Century Antwerp Tapestry

In 1986, we were presented with part of a once-larger tapestry entitled *Arithmetic* (Pl. 38). It is one of a group of seventeenth-century Antwerp tapestries displaying the liberal arts, the others being *Grammar*, *Rhetoric*, *Geometry*, and *Astronomy*. From the records, we know that during the 1950s at least three of the tapestries were sent to a London dealer, where they were repaired "in all good faith."

Prior to the arrival of *Arithmetic* at the studio, the tapestry was examined in situ at Cotehele House in Cornwall. A condition report and an estimate for conservation were prepared. The tapestry hung above a doorway in a space that was too small to accommodate its entire length. Approximately 50 centimeters of the lower edge had been rolled under above the door to make it fit the space. The tapestry was fully lined. The lining had been glued on around the edge, and there were obvious signs of glued patches within the body of the tapestry. Two of the other tapestries had been similarly treated, and all felt stiff to the touch. Further examination could be carried out only in the studio. It was decided to take this smallest tapestry, measuring about 2 meters x 1.3 meters (6'6" x 4'3"), as a trial piece in order to ascertain what conservation treatment was practical for the whole set.

Figure 1. Reverse side of Arithmetic *after removal of lining. Linen patches treated with Copydex adhesive.*

The dealer who had worked on the tapestries told us that a liberal quantity of Copydex adhesive had been used. At the time it had obviously been a matter of course, for the sake of economy and expediency, to cut out all of the offensive weak areas, comprising both wool and silk weft yarns. After removing the lining, we found that the back was covered with patches of linen thickly coated with Copydex (Fig. 1). These linen patches provided support backing for repair patches that had been neatly inserted into the prepared cut holes. Some of these inserted patches were actual pieces of tapestry, and others were pieces of cloth painted to look like tapestry weave.

Conservation Report

Job Ref. No. T102; *Arithmetic* tapestry fragment (from the Rose corner set), Cotehele, Cornwall; woven in Antwerp in the seventeenth century

Measurements: 2 meters x 1.3 meters (6'6" x 4'3")
Warp: Wool, 6 per centimeter (16 per inch)
Weft: Wool and silk

Condition Before Conservation

The tapestry had previously been repaired by adhering both tapestry and painted patches into the missing areas of the design. This adhesive had caused the tapestry to feel stiff while distorting its appearance—a condition further exacerbated by linen patches securely adhered onto the reverse of the tapestry. A close examination revealed that the left-hand border was not original; it was a later addition adhered at the same time as the other repairs.

A cut joined across most of the width of the tapestry had been repaired using a coarse linen thread that visually disfigured the work. A slight buckling in the lower part of the tapestry was probably caused by the manner in which the tapestry had been hanging over the years.

Treatment

The tapestry was vacuumed back and front. The adhesive used was probably Copydex, a 15-percent solution of sodium polyacrylate in water. Tests showed that the most suitable solvent for this adhesive was 1,1,1-trichloroethane (Genklene), as recommended by the manufacturer. However, the problem with this solvent for our purposes is that it swells the adhesive to a gel, which then has to be scraped away.

First, the linen patches were removed with swabs of the solvent, revealing thick layers of the still tacky adhesive. We removed as much of this adhesive as possible by applying swabs of solvent to small areas, allowing it to gel, and then removing it with a spatula. The painted patches and false border were removed at the same time. The staff had to wear thick PVC gloves and face masks as a protection against the solvent.

The tapestry was then passed through a trough of solvent and cleaned with Synperonic N and sodium carboxymethyl cellulose (SCMC) in softened water, with a final rinse of deionized water.

The tapestry responded to the cleaning process by becoming generally supple except for the borders, which were still quite stiff with adhesive.

Conservation Stitching

Because there remain fairly large areas of sound wool in the tapestry, patches of linen were used as a support behind weak areas rather than a full support of scrim. Plain dyed patches of a ribbed cotton fabric were used to repair the missing areas. We could not reuse the painted repair patches because they were so thickly coated with adhe-

side elevation front elevation

batten

batten

skirt

doorway

Figure 2. Diagram showing method of rehanging Arithmetic *over doorway. The lower edge was looped up and the surface protected from the wall by a "skirt" attached to the bottom of the lining.*

sive. Rewarping the holes and couching in the missing design would have damaged the remaining wefts around the perimeter of each hole; these areas in particular had been weakened by the rigorous process involved in removing the adhesive.

The central cut was secured onto a linen support patch. Anchor stranded cottons were used to repair the silk areas, and Appleton's and Medici wools were used for the wool areas. A Gütermann polyester thread was used to restitch fragile slits.

Method for Rehanging

In case the tapestry should ever need to be hung full length, it has been lined in the usual manner with preshrunk cotton sateen lining. Prestoflex (Velcro) was sewn along the top for hanging.

In order to mount the tapestry in the space above the doorway without causing further damage to the lower section, we looped up the bottom edge instead of rolling it onto a roller, which could cause extra stress and excess bulk. A special "skirt" was designed to protect the looped-up portion of the tapestry from abrasion against the wall surface (Fig. 2). This skirt can easily be removed.

The conservation took a total of 497 hours during the period of August 1986 to February 1987.

The success of the final treatment of this tapestry is debatable. Although one cannot deny that the structure and tactile quality are improved 100 percent, our treatment is markedly more visible than the previous treatment of adhered patches. Because of the many risks involved, for the safety of both the tapestry and the conservator, we have subsequently advised that the other glued tapestries remain untreated even though they have lost much of their quality as cloth. We do not have the facilities for safely treating large areas of adhesive with trichloroethane solvent. This approach becomes even more questionable when we consider the loss of fiber caused by physically scraping away the adhesive.

Some Conservation Problems Caused by Adhesives

I have been faced with the problems of various types of glue on tapestries on other occasions as well. Some years ago I was involved in mounting a tapestry onto PVA-treated net (Marko 1978:26–29). I now consider this treatment unsuccessful as a structural support as well as on aesthetic grounds. First, the structure of wool fibers naturally inhibits contact with adhesive unless the adhesive is liberally applied, and second, any great loss of yarn and design cannot be replaced by adhesion in a way that is visually pleasing.

In 1981 I had the task of removing a very coarse white net from the back of an eighteenth-century Arabesque tapestry by Joshua Morris (Fig. 3). That tapestry measures 2.5 meters wide by 2.1 meters high (8'3" x 7'). The net had been treated

Figure 3. Detail of eighteenth-century Joshua Morris tapestry prior to conservation, showing silk area surrounding parrot supported on coarse PVA-treated net.

with Vinamul adhesive, which in fact came away fairly easily when sprayed with industrial methylated spirits. However, some PVA still remained on the surface of small areas of wool and silk.

From previous records, I found that the silk weft in the lower portion of the tapestry had been impregnated with polyvinyl butyryl as a consolidant. Prior to wet cleaning, the silk area was swabbed with isopropyl alcohol (Propan-l-ol) in order to dissolve the polyvinyl butyryl, but it is uncertain whether all of the butyryl was removed. The silk felt a bit stiff once the alcohol had evaporated, though it became softer after washing.

The subsequent treatment of this tapestry raised the next problem I wish to discuss: how to support the resulting vulnerable silk area. Generally speaking, our conservation of tapestries involves the use of suitably colored threads worked across single warps to indicate missing portions of design or to strengthen weak areas. Every other warp is caught down in the first row of stitches, the alternate warps are secured in the second row, and so on. Regular intervals separate these rows of stitching; however, the distance between rows may vary according to the fineness of the original weaving, the extent of the damaged area, and sometimes the color that is being worked. Our method aims not only at providing support, but also at maintaining the quality of the original design as much as possible without resorting to restoration. Following from this, it may be necessary, for example, to work supporting stitches closer together in a coarsely woven tapestry to avoid a "thin" appearance in a given area. Likewise, when working with dark-colored wools, care is taken to avoid creating a "spotty" appearance that can attract the eye of the viewer and become a dominant feature of the tapestry. The yarns used are generally Gütermann's fine silk sewing threads; these are available in many colors, from which suitable shades or combinations of shades can be chosen to merge with the original silk weft. Medici or Appleton's embroidery wools are used for the wool weft, although they are not ideal because the twist can be rather loose. On occasion we resort to a natural wool yarn that has been specially dyed using Ciba-Geigy dyes.

Regularly spaced rows of stitching work well for most tapestries, but there are exceptions, and the Joshua Morris tapestry was a case in point.

I commenced work using a full supporting fabric of preshrunk linen scrim, with the idea of strengthening the weak areas with the usual spaced rows of couching. I soon found, however, that the silk weft was easily broken up by regular rows of stitching over every alternate warp. I changed from using a double thread of silk yarn to a single thread passed over and under four or five warps at a time, creating in the process much larger stitches on the surface. Where the silk was missing altogether I worked the stitches closer. At first I was worried that the large stitches would be too noticeable when the tapestry was rehung, but this proved not to be the case.

On another eighteenth-century tapestry, from Blickling Hall, Norfolk, I found that the most suitable stitch for supporting a large silk weft area of sky was laid couching, worked in a single thread of stranded cotton (or DMC) across the warps. The tapestry, woven in Leningrad, depicts Peter the Great. The surface of the weave was extraordinarily flat, and therefore the laid couching was absolutely invisible when the tapestry was rehung.

In 1975 I treated the third of a set of four seventeenth-century Flemish tapestries. At that time it was planned that the set would be hung together in a specially designed gallery. A decision was made to use Gütermann's polyester sewing thread 70/3 (instead of our usual silk yarn) for the support stitching of areas of silk weft. Wool was used for repair of the original wool weft. Wool and silk had been used exclusively to repair the first two tapestries of the set. It was envisaged that the tapestries would be monitored in order to compare the behavior of the yarns under

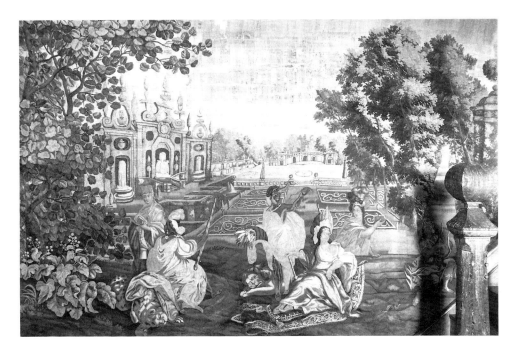

Figure 4, right. Eighteenth-century Soho tapestry, Africa, before conservation. Note weakness of silk weft in sky area.

Figure 5, above. Detail of weak silk weft.

actual display conditions. In the end, economic factors prevented the tapestries from being exhibited, and they have remained in storage. However, since that time I have found it necessary on occasion to use synthetic threads.

An Eighteenth-Century English Soho Tapestry

In 1985 the eighteenth-century tapestry titled *Africa* was treated in the studio. It is one of a pair; both show advanced degradation of silk weft over a large area in the upper half of the weaving (Figs. 4,5).

Conservation Report

Job Ref. No. T35; *Africa*, Packwood House; eighteenth-century (1733) English Soho tapestry.

Condition before Conservation

The tapestry was extremely dirty. The large area of sky woven in silk had undergone much previous repair and was very weak. There were also small areas of broken warps in the wool weft. Woven slits had been sewn with coarse thread. Although this thread was strong in places, it was pulling on the weft, and slits were beginning to gape. On the left side the original galloon was missing.

Treatment

1. Cleaning

The lining and all superfluous backing materials were removed. The tapestry was vacuumed front and back and made safe for washing by sewing the weak areas between sandwich layers of nylon net. Close attention was paid to the protection of the friable silk in the sky area. The tapestry was then washed in a 1-percent solution of Synperonic N detergent, SCMC, and deionized water. It was laid flat, blotted, and dried.

2. Stitching repair

The tapestry was attached to a three-roller tapestry frame and methodically stitched to a full support of preshrunk fine linen scrim. Vertical support lines were sewn at intervals of 8 inches: For every 20.3 centimeters (8 inches) of tapestry, 21.8

centimeters (8 1/2 inches) of scrim was allowed. Silk areas required the most repair. Some wool weft areas needed only to have slits mended.

Woven slits were sewn with Gütermann's Mara 30/3 polyester thread. For the silk sky area, Gütermann's sewing silk 100/3 was used in combination with Gütermann's polyester 70/3 in pastel colors for the couching repair; Mara 70/3 was used for slits, as the 30/3 was considered too thick and incompatible with the silk. This method of combining silk and polyester threads in the same needle was intended to blend the quality of the one with the strength of the other in order to render the large area of brittle silk sound enough so that the tapestry could be rehung on open display.

The condition of the tapestry required only a small amount of rewarping, for which we used British Mohair Spinners worsted wool warp dyed with Ciba-Geigy Lanacron dyes. Wool weft areas were couched with Appleton's and Medici crewel wools where appropriate.

Repair stitching was evenly spaced in both wool and silk weft areas. Previous repairs were removed in places where they were causing distortion and damage to the structure of the tapestry and where they visually disfigured the central image. A large repair marring the sky area was left in place because removing it probably would have caused extensive damage to the surrounding original silk. Elsewhere in the tapestry, heavy silk reweaving has flattened the design; this repair was also left in place because it covered a large area and because we had very little evidence that enough of the original weft remained on which to build an adequate replacement.

3. Finishing

A new galloon made of ribbed cotton fabric was dyed dark brown with Ciba-Geigy Solophenyl dyes and sewn to the left side with polyester thread, thus sandwiching the raw edge and completing the border.

The tapestry was lined with preshrunk cotton sateen lining fabric, which was sewn to the tapestry with polyester thread in evenly spaced rows of vertical stitching. The lining was sewn to the tapestry on all four sides, allowing a 5-centimeter (2-inch) pleat along the bottom edge that can be released in the future in case the tapestry should "drop" dramatically or in case changing environmental conditions should cause the lining to shrink. A Prestoflex (Velcro) fastener was attached along the top edge using a herringbone technique.

The tapestry was rehung at Packwood House on August 6, 1986 (Pl. 39). The conservation took a total of 622 hours.

These large areas of silk weft, usually woven in the upper portion of a tapestry where the silk has been under great stress from carrying the weight of the hanging, are the areas that present special problems for me. For example, if the tapestry is to be rehung, how can I strengthen these areas to take the weight? How should I restitch them? And with what type of thread? I continue to use a full support of linen, but I often change the sewing thread and stitching pattern according to the qualities of the original weft. Sometimes the area is so fragile that I would prefer not to work it with a needle at all. But then if the tapestry must be rehung, what will happen to these areas if I do nothing?

For the present, I am concentrating on adapting my techniques in order to disturb the remaining original silk as little as possible and thus to cause the least amount of visual interference. This is often extremely difficult if not impossible. I wish there were a magic solution.

Acknowledgment

I wish to acknowledge Anne Amos for work on the seventeenth-century Antwerp tapestry and Laura Drysdale for work on the eighteenth-century Soho tapestry. I would also like to thank the National Trust and the Victoria & Albert Museum for their permission to publish the photographs illustrating this article.

References

Marko, Ksynia

1978 Experiments in Supporting a Tapestry Using the Adhesive Method. *The Conservator 2*.

Biography

In 1982 Ksynia Marko established the Textile Conservation Studio, London. She worked for Karen Finch, before joining the Victoria & Albert Museum in 1973. She served as Senior Conservation Officer in charge of tapestry conservation while also teaching embroidery at the Royal School of Needlework. In 1975 she was awarded a scholarship to study restoration and conservation techniques in Europe. Her articles have appeared widely in conservation journals.

The Conservation/Restoration of the Sixteenth-Century Tapestry
The Gathering of the Manna

Yvan Maes

This congress has brought together textile specialists from both public institutions and private workshops. Here in Belgium the differences between these two realms are vast in terms of their financial means and the amount of time each can afford to spend on the restoration of tapestry. At present, we at the Royal Art Tapestry Workshop Gaspard De Wit are obliged to reduce the costs of conservation drastically. In treating certain works we can allow only 10–25 percent of the amount of time spent in a public institution for treatment of a similar work.

Given these conditions, what can a private workshop like ours contribute to this congress? And, given these financial limitations, can we still perform quality work in the treatment of tapestries?

In answer to the first question, private workshops are in a position to contribute research aimed at finding faster and more efficient treatment methods—in other words, ways of enhancing productivity.

Productivity is a word one seldom hears at a congress of this kind, and some might consider the very concept incompatible with the respect due to works of art. In considering the needs and concerns of a private workshop, this objective cannot be neglected. And, in my view, the problem of productivity extends to the public institutions as well. We believe that research aimed at finding more productive and efficient restoration methods is essential to the field in general. Tapestry weaving as an industry once involved thousands of people; each important work represents easily ten thousand weaving hours. Considering the amount of time required by classical methods of restoration, the number of textile conservators today seems completely out of proportion regarding the conservation of this patrimony.

The consequence of this situation is that, in general, restorations are planned piece by piece. It is an exceptional case when an institution is able to develop a program for the conservation of a whole series of tapestries or for an entire collection. It has always been the policy of our workshop to develop and propose comprehensive restoration programs to our museum clients, e.g., the Gruuthuse Museum in Bruges and the Musée d'Art Ancien in Brussels. This approach can and should be implemented if we can develop more efficient and cost-effective conservation/restoration methods.

The second contribution offered by the private workshop is a sensitivity to the tapestry itself. Our work is not restricted to the restoration of historic tapestries;

Figures 1,2. The warp and the silk previously repaired with a very thick knitting thread.

we also weave modern tapestries, using the weaving techniques of five hundred years ago. This part of our work gives us a particular awareness of the decorative role, the monumental character, and the sumptuous nature of tapestries. It is our view that some conservation methods neglect these specific qualities, which we feel uniquely suited to address.

Now let us consider the specifics of our treatment approach by way of a recent example, *The Gathering of the Manna*.

According to Guy Delmarcel, curator of the Department of Tapestries at the Musées royaux d'Art et d'Histoire in Brussels, *The Gathering of the Manna* is the missing link in a set of eleven Moses tapestries. Ten pieces of the set have been preserved in the castle of Châteaudun, France, a property belonging to the Services des Monuments Historiques. *The Gathering of the Manna* completes the set. It is important to note that these tapestries represent almost the entire furnishing of the castle; their decorative role is therefore essential.

The set was woven in several workshops in Brussels—one of them that of Jan Ghieteels—in about 1545. The models, if not the cartoons themselves, were provided by a northern Italian artist whose style was influenced by Giulio Romano. The Châteaudun set is probably the first edition of these cartoons, which were used as the basis for later sets, also woven in Brussels and now preserved in Madrid, Vienna, and elsewhere. In the view of Dr. Delmarcel, this first edition was commissioned by a member of the Gonzaga family.

The Gathering of the Manna measures 5.7 meters wide by 3.6 meters high, totaling more than 20 square meters. With its high density of 6–7 threads per centimeter, the tapestry is of top quality in all respects. The entire series is in very bad condition, however, and *The Gathering of the Manna* was perhaps in the worst shape of all. It was a real wreck.

For the treatment of this tapestry, we proposed a restoration/conservation plan to the Caisse Nationale des Monuments Historiques et des Sites of France. In our proposal we attempted to demonstrate that, with only a very limited number of working hours, it was still possible to conserve a work that had become a ruin—without compromising the present standards of conservation treatment or the decorative function of this particular tapestry. This was our challenge.

Condition of the Tapestry

Figure 3. Detail showing the condition of the nineteenth-century restorations.

The condition of the tapestry can be described as follows:

- The tapestry had become stiff as cardboard from hanging on a humid wall.
- The silk was so damaged that no less than 75 percent of the original silk had been lost (Pl. 40).
- The yellow warp, which was turning brown in places, had been repaired with a very thick knitting thread (Figs. 1,2).
- There were enormous holes in the weft (some as large as 100 cm x 30 cm) next to each other on the left side of the tapestry (Pl. 41).
- In several places the warp was rotten or had disappeared completely (Pl. 42).

The nineteenth-century restorations posed a special problem: They were not so bad that they had to be removed; on the other hand, they could not be fixed easily because they fell to pieces when we worked on them (Fig. 3).

Treatment

In the remarks that follow, I will address myself to issues of cleaning, lining, dyeing and materials; I will then discuss our specific conservation/restoration methods and hanging procedure.

As mentioned, private workshops such as ours are often forced by financial necessity to find compromises in our approach to conservation. The cost of cleaning, lining, and materials amounts to less than 25 percent of the entire cost of treatment, yet these are incontestably crucial aspects of the total treatment. We therefore try to avoid compromises during this phase of the work. We use techniques developed in other restoration institutions such as the Institut Royal du Patrimoine Artistique. In the following paragraphs, I will focus chiefly on some of our adaptations of these methods.

Cleaning

We begin by testing a sample in boiling water for colorfastness. This step is essential where nineteenth-century restorations are present.

Temporary consolidation of the tapestry follows. This step was especially necessary in the case of *The Gathering of the Manna* because some parts of the tapestry had become completely disconnected because of gaps in the weft.

The cleaning is done in a custom-made fixture built in the following manner. Four wooden beams cut to the dimensions of the tapestry are positioned on the floor as a frame for sheets of plastic that form the wash surface. The tapestry is spread out flat on this surface and immersed completely in water and neutral detergent. When the first side is clean, we roll the tapestry slowly on a plastic tube, turn it over, and unroll it carefully in order to avoid any distortion of the warp and weft caused by moving or manipulating the tapestry. We then proceed to clean the second side.

The tapestry is sponged by pressure applied by hand or foot, depending on the condition of different parts of the tapestry. For this procedure we do not use sponges fixed to our feet because experience has shown that they do not remain perfectly flat while we step up and down. This can cause friction, which we must avoid at all costs. Instead, we prefer to use large white sponges measuring approximately 1 meter x 50 centimeters. These sponges form perfectly flat layers with the tapestry on the bottom of the bath. This method eliminates all friction. Eliminating friction is especially important for cleaning large tapestries, and small variations in the level of the floor sometimes make it hard to obtain a completely flat surface. Water depth might vary from one area to the next, even causing the tapestry to float in the deeper areas.

When one section of the tapestry is clean, we proceed by moving the sponge to the next section.

We rinse the tapestry four to six times, depending on the soap residues. We use demineralized water for supplementary rinsing.

We dry the tapestry first with white towels applied to the entire surface, then with blotting paper.

We spread the tapestry out on the floor, flattening it completely by working rollers out from the center in the direction of the warp. Lead weights keep the damp tapestry fixed flat while it dries.

For the last stage of drying, we heat the floor under the tapestry at a very low temperature. With this method, the tapestry dries completely in a few hours.

Materials

For lining and consolidating, we use the same high-quality bleached linen used at the Institut Royal—namely, a very fine, strong textile with a high density of weaving. It is prewashed twice to avoid shrinkage.

The unbleached silk and the linen used for consolidation are specially dyed. The metallic dyestuffs and dyeing methods used at the Institut Royal have demon-

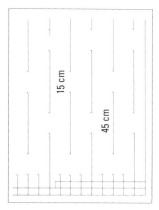

Figure 4. Pattern of stitches for attaching the lining.

strated maximum fastness with respect to light. We use these same methods except that we manage the dyeing process differently, as I will discuss below.

Our tests have shown that with two prewashing treatments and a third bath at 90 °C for the dyeing, even a large consolidation textile (more than 4 m in length) will not shrink when subjected to a fourth bath at 30 °C for cleaning.

Lining

We sew the lining to the tapestry in staggered, overlapping vertical rows of stitches 45 centimeters long, separated by intervals of 15 centimeters (Fig. 4). It is common practice to perform this operation while the tapestry is hanging; yet tapestries show irregularities in the upper part when they are hanging. We are reluctant to fasten down those irregularities onto the lining. We have therefore developed our own method of working on the tapestry while it is lying flat on a table.

We work on a large worktable, 4.5 meters x 3.5 meters, which can be extended if necessary (Pl. 43). A roller 4.2 meters long is fixed to one end of the table. Next to the roller, along the width of the tapestry, is an opening in the table approximately 2 centimeters wide through which the lining is sewn to the tapestry.

First, the lining is placed flat on the table and held in position by weights. Then the tapestry is placed on the lining, unrolled from its plastic tubes, and adjusted into position so that it lies as flat as possible on the lining. Planks lined with synthetic rubber to prevent slipping are placed on top of the tapestry on each side along the height, and the lead weights are moved onto the planks. Traction on the planks draws the tapestry and lining across the opening at increments of 15 centimeters so that the stitches can be sewn. The textiles glide easily across the table because it is well varnished; the planks hold the two textiles together perfectly flat and ensure that they move together throughout the procedure.

We prefer this method for sewing the lining because in this way the weight of the tapestry is distributed evenly over the entire surface, allowing it eventually to hang flat.

Documentation

The extent of our documentation depends on our client's requirements. In the case of *The Gathering of the Manna* by exception, we have taken about two hundred slides of the tapestry before, during, and after treatment. We also supply details of our work noted on tracing paper—e.g., new woven parts, new warp, consolidation textiles, consolidation lines, etc. In addition, we supply samples of the colors we tested as well as samples of the materials we used.

Conservation/Restoration

This part of the treatment proceeds in four stages: the first consolidation, the treatment of the holes in the silk weft, the treatment of the holes in the warp, and the final consolidation.

1. The first consolidation

It is our usual practice to attach consolidation patches whenever necessary before we mount the tapestry on the restoration loom. As mentioned, these linen patches are prewashed twice and dyed to match the areas they are meant to support. *The Gathering of the Manna* required consolidation on 70–75 percent of its surface, essentially on all borders that appeared shredded. To cope with this severe damage, we decided to cover the entire tapestry with a custom-dyed consolidation textile in four separate vertical panels.

Figures 5,6. Damage to the silk in this area made it difficult to distinguish dust trapped in the warp from thread residues we have to conserve.

It turned out to be impossible to attach the consolidation panels before mounting the tapestry on the loom. Most of the remaining silk was so rotten that it was creating a considerable amount of dust as we worked, even to the extent that it was difficult for us to differentiate the dust trapped in the warp from the thread residues we were trying to conserve (Figs. 5,6). If we had attached the panels first, it would have been impossible to avoid accumulating dust between the tapestry and the consolidation textile.

We built a custom frame to which we attached the consolidation textile. This frame was positioned under the restoration loom. We attached the consolidation textile only along one edge so that we could evacuate all dust through the other sides.

2. Treatment of the holes in the silk weft

The enormous holes in the silk had destroyed the visual composition of the tapestry. All that remained of the three main figures on the left side, for example, were the yellow warps that were in the process of turning brown in some places. This essential part of the design was ruined by these ugly effects. To my knowledge, there is no classical method of conservation that could have solved this aesthetic problem.

We therefore developed our own method aimed not at recovering the original composition, which was completely lost—in this context it would also not have been affordable—but rather at incorporating a basic shade that would be consistent with the main elements of the composition. Our purpose was to diminish the impact of the enormous gaps so that the original parts could again be appreciated in terms of the overall composition. We also wanted to maintain a clear differentiation between original and newly woven parts. Finally, we wanted to ensure that the warps would be firmly secured.

Now, let us consider the distinctive features of our approach for treating the gaps in the weft. In the case of *The Gathering of the Manna*, we were dealing exclusively with silk weft, which is, in my view, the greatest problem we face in the restoration of tapestries.

First, instead of working with one or two threads of silk in the usual manner, we work with a mixed blend of six to ten very fine silk threads, selected according to the fineness of the tapestry. For *The Gathering of the Manna* we used a mix of eight threads. This method offers several advantages.

Close inspection of a single "passé" (one woven weft line) reveals that because the eight elements are not twisted, they tend to flatten out between the warp and lie more or less parallel to each other (Fig. 7). When this weft line is not squeezed between two others, the eight colored elements cover more of the white warp in a single pass than is possible using the conventional method. This innovation offers a more efficient way of covering the white warp and of restoring the basic color of the missing weft.

The second advantage of our method is the color accuracy we can achieve within our limited means. Under ideal circumstances, we would custom-dye each color separately, which is a very time-consuming process. Indeed, a very close analysis of the blue, for example, shows that the threads are composed of three different shades: deep blue, argent grey, and ochre. Obtaining exactly these three shades through a custom-dyeing process requires a considerable amount of work, which has to be repeated for each color to be restored.

We abandoned the system of custom-dyeing threads for each missing color. Instead, we dye threads in a color scale of more than a hundred shades, those most frequently required for tapestry restoration. Because we work with very fine threads, we can blend these standard shades to achieve the same effect as with custom-dyed

Figure 7. Detail showing the eight untwisted weft threads lying more or less parallel in each "passé."

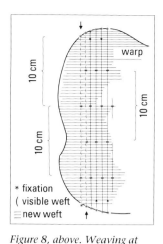

Figure 8, above. Weaving at specific regular intervals.

Figure 9, right. Pattern of reweaving at regular intervals and securing the threads in the consolidation textile.

thicker threads. With this wide color scale, we can achieve very subtle effects similar to those of the original tapestry.

This method entails a completely different management of the dyeing process. Instead of researching custom colors and painstakingly dyeing the threads by trial and error, we simply dye the threads systematically and quickly in a series of standard mixtures of the three primary colors. The threads are then kept in storage until they are needed to produce a custom blend. We believe this system offers an improvement in color accuracy as well as time management and cost efficiency for cases where financial limitations are present.

The second distinctive feature of our method is the technique of weaving at specific regular intervals (Fig. 8). This actually is a conservation technique, which, at the same time, solves some aesthetic problems as well.

This technique works as follows: Each new woven line begins with a fixation stitch in an undamaged part of the tapestry at the top of the gap and ends at the bottom in another undamaged part with another fixation stitch. The eight-filament threads are woven up and down through the warp and secured every 10 centimeters by stitches through the consolidation textile. Then, returning from the bottom to the top, the threads are secured again at the same intervals, with stitches overlapping each other every 10 centimeters (Fig. 9). Reweaving at this distance created, in this case, a density of 3–4 lines/centimeters; the resulting structure of the textile inhibits the woven vertical lines from moving to the left or right and ensures that the warp is securely anchored to the consolidation textile. The new woven structure created in this manner is essentially lighter than the original or than the weft structure created by reweaving with normal density. A lighter structure is better for the conservation of the surrounding original parts and allows conservation of more original areas; the heavier the new weft, the sturdier must be the original part in which it is anchored.

The second advantage of this technique is, of course, aesthetic. As mentioned, the three important figures on the left-hand side of *The Gathering of the Manna* had disappeared completely, replaced by a huge, visually disturbing brown area. Through our restoration method they have once again become visible in their basic colors of blue, yellow, and yellow-green, which are essential to the composition of the tapestry (Pl. 44).

Of course this method cannot bring back the details of the original design. Reweaving the details of tapestries in poor condition is, in any case, always problematic. First, there is a financial consideration: Reweaving details according to the original cartoon (when it is possible) requires at least three to four times more work. Second, there is the inevitable problem of the alteration of the restored colors over time, which becomes evident in cases where illusionist restoration has been performed. Finally, we are always faced with interpretation criteria, which vary accord-

ing to the specific understanding, values, and prejudices of each restorer and each century. By limiting our efforts to restoring the basic shade of the gap, we avoid the above problems. This approach makes the tapestry as a whole more readable and focuses attention on the original parts rather than on the restored areas.

We have applied this method, which is a compromise between conservation and restoration, for quite a number of years. In 1984 at the Institut Royal we presented the treatment of a tapestry depicting Romulus and Remus, which we restored for the Musée Royal des Beaux Arts in Brussels using this method. *The Gathering of the Manna* is, however, the first time we have used this approach on extensive holes in the weft (as mentioned, some as large as 1 m x 30 cm).

We gained much insight from the restoration of this tapestry, and at times we had to adapt our method. The choice of colors has proved to be a crucial element, even if the new woven parts are added only to enhance the value of the original elements. In the blue area, for example, we first used three basic colors: dark blue, argent grey, and ochre. However, when the tapesty was viewed from a distance, it turned out that the yellow warp provided the ochre shadow we needed. We therefore changed our mix to the two shades of blue, four threads each. This adjustment gave the blue shadow more presence than it had had previously.

3. Treatment of the holes in the warp

In order to honor the aesthetic issues involved in the restoration of this tapestry, we faced a choice between two approaches to the problem of the holes in the warp:

- The system I call "patchwork," that is, using textile patches selected for their fabric and color
- The classical system that entails introducing new warp and reweaving the missing parts

We have chosen the classical method, using a custom-made wool warp. It is also custom-dyed in one color only to limit the cost (Pls. 45,46). Usually our color matched the original, although in some very damaged areas it turned out to be too light. We now have at our disposal a large color scale of dyed warp in yellow and brown.

We never introduce new warp into a weak area of the silk surrounding a hole in the warp. In cases such as this we make bridges: At the end of the hole, the new warp is passed behind the consolidation textile and attached farther away from the hole in a sturdy wool part surrounding the weak silk (Fig. 10).

We used the classical method for the following reasons:

The holes in the warp were not numerous, making it possible to preserve a uniform textile structure throughout the entire tapestry.

In cases where there are not too many holes in the warp, our experience has shown that it is more time-consuming to attempt to imitate the original textile structure with custom-made patches than to introduce a new warp.

Our experience with patchwork has been disappointing. The differences in the structures of the two textiles create problems that sometimes appear only after a lapse of time.

Finally, the tapestries restored with new warps in our workshop more than thirty years ago—e.g., *The Story of Jacob*—do not show any problems.

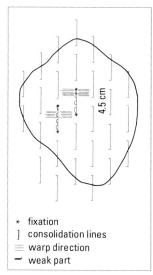

* fixation
] consolidation lines
≡ warp direction
~ weak part

Figure 10, above right. Detail showing the new warp forming a bridge on the consolidation textile over a weak silk part of the tapestry.

Figure 11, above. Pattern of stitches for consolidating weak areas.

4. Final consolidation

The tapestry required still further consolidation to deal with problems caused by the nineteenth-century restorations. This phase of the treatment turned out to be the most difficult of all.

This consolidation consists of rows of stitches 4.5 centimeters long and overlapping in the same manner as for the lining, about 1.5 centimeters apart (Fig. 11). These rows are spread at intervals of about 3 centimeters.

Given our restoration system of regular stitches every 10 centimeters, I have come to the opinion that this additional consolidation is not absolutely necessary. However, I will leave this matter to the judgment of my peers. Additional consolidation lines do not add greatly to the cost, and they have been made in these parts too. Plate 47 shows the tapestry in its completed, restored state.

Hanging Procedures

The castle of Châteaudun is not provided with a heating system. All of the tapestries are hanging on humid walls, attached by nails on wooden beams. Under these circumstances, variations in temperature and humidity can provoke dramatic problems, such as the one that developed during the very cold winter of 1986-1987. A sudden change in temperature led to an exceptional concentration of humidity on the walls. The tapestries soaked up the water, which then converted to ice, causing considerable damage by its weight.

We believe that in view of these conditions it is important for us to propose a new system for hanging the tapestries so that we can hang them or take them down at a moment's notice. We proposed the system used in our own exhibition rooms in our abbey. Using this system, it takes four persons one-half day to remove all the tapestries in the castle. The system is designed to prevent any irregular tension in the weft that can damage the work.

The tapestry is attached with Velcro strips to a wooden plank. This plank is not affixed directly to the wall but rather is attached by means of nylon cords. These cords suspend the plank from its front so that the plank—with the whole weight of the tapestry—remains parallel to the wall. In this way we avoid the practice we have sometimes seen of using counterweights on the back of the tapestry in order to hold the plank parallel (Fig. 12). The cords run through copper pulleys fixed to the wall. Extending down from the pulleys, these cords can very easily be attached with the same system used for boat equipment. The weight of the tapestry clamps the cord firmly in place; it can be released by gently pulling the cord away from the wall.

Small bumper wheels attached to the back of the plank keep a steady distance of approximately 10 centimeters between the wall and the plank and, of course, the tapestry. Finally, we also supply a protective cover, 4 meters x 6 meters, and a plastic tube, 4 meters long and 15 centimeters thick. These items do not cost more

Figure 12. The system for hanging the tapestry.

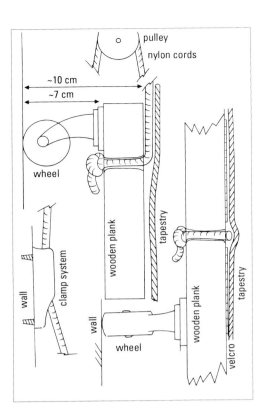

than $100. They allow us to hang and take down a big tapestry very easily, quickly, and without damage.

The hanging proceeds as follows: When the tapestry is not hanging, it remains rolled on the plastic tube. The protective cover is laid on the floor, and the tapestry is unrolled until it is completely flat. The Velcro of the tapestry is fastened to the plank along a line drawn with pencil on the Velcro. This line is predetermined by tests carried out in the workshop to ensure that the tapestry hangs perfectly flat. The plank and the tapestry are hoisted up by the cords. The tapestry, together with the protective cover, slides across the floor as it ascends the wall without any irregular tension. The wheels on the plank hold the tapestry at a distance of 10 centimeters from the wall in order to provide good air circulation between the wall and the tapestry. The clamp system fixes the tapestry in the right position at once.

Taking the tapestry down is also very easy. First, the protective cover is opened up on the floor. The tapestry is brought down slowly until the bottom of the tapestry is lying flat on the floor. Then the tapestry is rolled up on the plastic tube with the tapestry facing out and the lining facing in. Rolled in this way, it can be put in storage.

Conclusion

This work presented the following challenges:

1. To fulfill the new criteria for quality, as established by important research institutions such as the ones represented at this congress
2. To respect a classical perception of the decorative and monumental function of tapestries in old buildings
3. To reduce drastically the number of working hours necessary for restoration

This work required approximately one thousand hours of labor—two months of work for three people. It is only by compressing the time and labor required for each treatment in ways such as these that we can hope to extend our work beyond its

narrow scope and address, instead, the needs of tapestry series and collections treated in whole rather than in part.

I was especially convinced of the need for a new approach when I went to hang *The Gathering of the Manna* in Châteaudun after its restoration. There I heard from the head of the Servicès de Monuments Historiques of France that the catastrophic condition of the other pieces in the series is not exceptional; rather, it exemplifies the condition of many of the tapestries hanging in the castles of the Loire.

Biography

In 1980 Yvan Maes assumed the position of director of the Royal Art Tapestry Workshop Gaspard De Wit, Mechelen, Belgium, a private restoration workshop serving museums throughout Europe and Japan. He received his education in art history and business administration at Catholic University of Louvain and further specialized training under his grandfather, G. De Wit.

The Treatment of Two Sixteenth-Century Tapestries at the Institut Royal du Patrimoine Artistique

Juliette De boeck, Michelle De Bruecker, Chantel Carpentier, Kathrijn Housiaux

The Institut Royal has engaged in the treatment of tapestries for more than fifteen years. At the beginning, we followed the classical reweaving procedure, but since that time we have gradually evolved toward an approach of pure conservation. The modern materials do not blend entirely with the original ones. The new wool is too soft and "hairy"; even after shaving the new wool, the rewoven parts reflect light in a way that differentiates them from the original. Reweaving always implies an identical interpretation of the original cartoon.

In accordance with the general topic of this seminar, we will describe the treatment of two early sixteenth-century Brussels tapestries belonging to the Musées royaux d'Art et d'Histoire: *The Lamentation* (298 cm x 328 cm) and *The Baptism of Christ* (224 cm x 267 cm). The central group of *The Lamentation* is very similar to that of a painting attributed to Perugino in the Uffizi in Florence. Both tapestries are made of wool, silk, and metal threads, with 8–9 warps per centimeter in *The Lamentation* and 7–8 warps per centimeter in *The Baptism of Christ*.

The Lamentation (Fig. 1)

Preliminary Examination

The tapestry was dusty and brittle. Removing the lining, we found strips of paper and fabric glued fast to the back of the tapestry in a quadrangular pattern. Many silk threads had disappeared, leaving bare warps, some of which were broken. Several of the modern dyes used for previous restorations were evidently not colorfast.

This tapestry shows traces of a very peculiar technique. Touches of paint were used to enhance the flesh tones and to underline lips, eyes, etc. The transparent effect of the paint is similar to makeup. This makeup was introduced after the weaving process and executed by "Afzetters."

Treatment

The presence of unstable materials prevented us from immersing the tapestry in water.

The removal of the glued paper and fabric strips was very difficult. The only way we could soften the glue was with xylene, which unavoidably caused little bits of brittle silk to come off in the process. This difficulty illustrates the danger of using glue on old fibers. Afterwards, the tapestry was vacuum-cleaned on both sides.

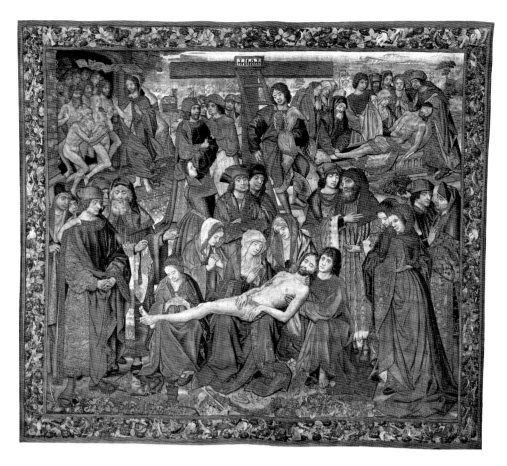

Figure 2. Cleaning the tapestry with damp sponges.

The dirt was eliminated by treatment with damp sponges (Fig. 2). The sponges were frequently rinsed in demineralized water and moistened with clear water. The sponges do not leave wet spots on the tapestry. After this procedure, the wool felt softer and became easier to handle.

The slits were resewn with cotton thread in blanket stitches, as necessary, in places where warps and wefts were not missing. The tapestry showed a lot of damage along the borders. At the time (in 1981), we decided to reweave the brittle parts. In doing so, we were compelled to fill in missing details from our imaginations, which goes against the grain of respect for the authenticity of the work of art (Figs. 3, 4). Reweaving was thus limited to the borders, and the rest of the tapestry was consolidated by sewing the fragile areas onto fine linen linings dyed to blend with the surrounding composition. These linen patches were sewn to the back of every damaged area. The tapestry was mounted on a loom. The fragile surfaces were fastened to the lining by stitches crossing over every 4 centimeters in the weft, up and down, in overlapping rows.

Figure 3, right. Detail during treatment.

Figure 4, far right. Same detail as in Fig. 3, after treatment.

Figure 5, right. Detail before treatment.

Figure 6, far right. Same detail as in Fig. 5, after treatment.

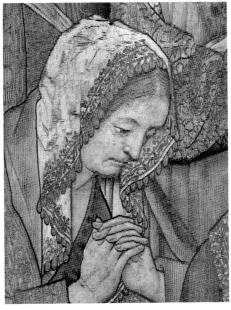

Figure 7, right. Detail shown during treatment.

Figure 8, far right. Same detail as in Fig. 7, at the conclusion of treatment.

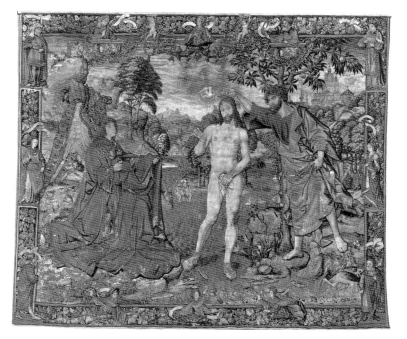

Figure 9, right. The Baptism of Christ, *sixteenth century, Brussels, shown before treatment.*

Figure 10, above. Detail showing an old repair.

The silk thread was cut after each row of stitches. Uncovered warps were sewn to the lining with stitches following the direction of the twist (Figs. 5,6). In making these stitches, it is important to extend the consolidation beyond the damaged areas into the sturdy ones.

The mending of the large lacunae always presents special problems. In *The Lamentation*, the design of the face of one of the figures in the central group had been destroyed. We filled in the losses with new warps attached to the linen lining and some weft stitches sewn at the ends of the original warps (Figs. 7,8). We had the opportunity to apply the same technique to a much larger lacuna on another tapestry, *Leonide Steals the Letters of Astrea from the Sleeping Celadon*, a sixteenth-century tapestry from Bruges. The scarf of Leonide was restored by securing the damaged area to a linen lining; warp-like threads were sewn onto the lining and covered with new wool and silk wefts in order to reconstruct the drawing. This was made possible by the fact that the cartoon of the tapestry was at our disposal. The aesthetic effect was particularly convincing (Pls. 48,49). The treatment is completely reversible because the embroidery that simulates the weave is sewn only on the lining. It is very important to take care that the missing warps and wefts blend well with the original weaving in texture and color.

Finally, the tapestry is completely lined with a thin white linen fabric, which is provided with a strip of Velcro stitched by machine along the upper edge. The lining is first attached at the top with a horizontal row of stitches. The lining and the Velcro are then secured by vertical rows of running stitches spaced 7.5 centimeters apart. The rest of the lining is fastened to the tapestry by rows of running stitches 45 centimeters long, passing over 2.5 centimeters at the back and over one warp at the front. The sides are attached to the tapestry over the top two-thirds; the bottom hangs loose to prevent it from sagging.

The Baptism of Christ (Fig. 9)

The tapestry was dusty and brittle. After removing the lining, we discovered patches of heavily starched linen supporting weak areas (Fig. 10). We took off those restorations because they disturbed the fine quality of the tapestry. We left only the restorations of the red borders because they were too numerous and because they did not distort the tapestry's visual impact.

We applied the same cleaning and conservation methods used for *The Lamentation*, but without reweaving.

Biographies

Juliette De boeck, a native of Belgium, heads the textile workshop at the Institut Royal du Patrimoine Artistique where she was trained in textile conservation under Dr. Masschelein-Kleiner. Her published papers document some of the projects undertaken by the workshop since she assumed her position in 1977.

Michelle De Brueker, a native of Brussels, joined the staff of the IRPA textile workshop in 1979 after receiving her training there.

Chantal Carpentier is also a native of Brussels. She received her training at the IRPA textile workshop and joined the staff as restorer in 1983.

Kathrijn Housiaux was born in Liege. Like her coauthors, she studied textile restoration at the IRPA textile workshop and joined the staff in 1979.